What Is Color?

WH IS

IS

COL

50 Questions and Answers on the Science of Color

Arielle Eckstut & Joann Eckstut

Abrams, New York

Contents

*Color is
a pigment
of our
imagination.*

MARK REA

1 | What Is Color?

In the fall, do the leaves on the trees still change color if no one is there to see them? If you're a new student of color, then your answer is probably a resounding OF COURSE! Why would you have to be present for the leaves to change colors if the colors are inherent in the leaves? Here's the astonishing thing: They're not. Inherent that is. Colors don't exist until we see them. There's no such thing as color without the eyes and the brain. The truth is that most other animals—and even some humans—don't see red, orange, yellow, and green leaves when they look at fall foliage in a forest, because different brains process visual information differently. This idea that color does not exist outside of our perception is difficult to swallow because it counters what appears to be cold, hard reality.

What then *is* color, anyway? Here's a concise definition: Color is a neurological phenomenon—a perception of the outside world that the human brain creates. In order to create this perception, our brains obey the physical laws of the universe, but often in counterintuitive ways. Experiences, collective and individual, play a big role in the colors we see or that we associate with any given object as well. In other words, as you will see on every page of this book, color is very, very complicated.

Human brains have gone to extraordinary lengths to give us color vision. And people have spent millennia trying to contain, categorize, and formulate systems in order to understand this gift. We are often taught that these containers, categorizations, and systems are some form of natural law, but really they are just human inventions meant to impose order on the unorderable. Just as we've invented intervals of time so that we all show up to work when we're supposed to, musical notes and scales

so that we can compose symphonies, we've also invented the colors of the rainbow in order to measure the infinite.

Even though color vision comes to us effortlessly, it is so complex that neuroscientists who specialize in color vision don't agree on how and why people see color. We know because we interviewed them. It's surprising how much of color vision is still up in the air, how much is being discovered, and how new the science of color vision is. That said, hundreds of years ago, artist/scientists like Leonardo da Vinci asked many of the same questions we're still asking today.

Naively, we considered ourselves color experts when we started writing this book. After all, we had already written a book called *The Secret Language of Color* that took a broad view across nature, culture, and history, although with comparatively little emphasis on the hard science of color. We quickly realized we were more emperors with no clothes than Josephs in technicolor dreamcoats. Our struggle stemmed from the fact that color science touches so many disciplines: physics, chemistry, neuroscience, biology, anthropology, linguistics, history. The list goes on and on, which is why it's hard for anyone to call themselves a color expert. The physics of color alone was dizzying even to Einstein.

Sadly, we are not Einstein. We are a mother-daughter team with lots of the same interests but different paths. When we started researching *The Secret Language of Color*, we were designers and entrepreneurs who had been using color in both of our businesses for decades, but neither of us had studied the science of color. Joann is a former fine artist–turned–interior designer who specializes in color. Arielle is a writer who co-founded a company called LittleMissMatched, which started by selling socks that don't match in packs of threes, but eventually produced everything from bedding to clothing to furniture—all with color leading the way.

When it came to writing this book, our lack of scientific expertise turned out to be a blessing. Because we hadn't spent years steeped in the

science of color, we didn't come at the subject with the kind of assumptions about what most people know that experts have. We were determined to explain complex ideas in a way that anyone from any field could pick up and not just understand but enjoy.

What Is Color? is loosely divided into five sections. It will take you from color's origins as light in the physical universe, to our brain's ability to sense light and perceive color, to relationships among specific colors (like primaries and complementaries), to showing how color has been codified and categorized for artists and industry, and finally to touch on the experience of color and how that has a profound effect on what humans see. It's a book we wished we had as students and a book we'd like to have as a reference on our desks.

We've designed this book so that you can acquire different levels of knowledge based on how you read it. Each question is broken down into three paragraphs. Okay, a couple have four. Each paragraph gets progressively more detailed. You could read just the first paragraph under each question [■] and come away with a basic knowledge of color that will put you ahead of the majority of people who use color on a daily basis. Read onto the second paragraph [■] and you'll get even further ahead. Read all three paragraphs [■] and you'll come out of this book with a solid understanding of the depth and breadth of the science of color: how we see color, the difference between the color of light and the color of things, how different color systems work, how different properties of color affect how we see color. And much more.

When we set out to write *What Is Color?*, we also knew that many visual learners would read it. That's why the words are balanced by graphics. What's funny is that lots of books about color theory are mostly in black and white. We wanted a book in which you could start with the words or the graphics. And we wanted to make sure there was plenty of color to guide the way.

The questions we've chosen and the order that they're in are by no means definitive. In the process of writing this book, we changed the fifty questions the book answers far more than fifty times. We re-arranged the order of the questions endlessly and would still be reordering them if the book didn't have to go to press. There's a saying in the business that a book is never done. We can say definitively that this book is and always will be a work-in-progress.

It's easier than you might think to spend a lifetime working with color without understanding much about it. Not too long ago, we were giving a presentation to decorators, interior designers, architects, and paint contractors. The majority of these professionals had been working in their fields for years, if not decades. After our talk, we were chatting with a group of people and a funny, warm guy in a charcoal bespoke suit said, "I want to admit something: Despite five years of architecture school and thirty years of my own practice, almost everything you talked about today was new to me." We've heard similar comments from people in all kinds of disciplines—marketing professionals, printers, fashion designers, fine artists, lighting designers, art teachers, even scientists who have only approached color from their particular field and vantage point.

Artists and designers of every stripe, marketers, manufacturers, and even a customer trying to figure out if a brown chair in the showroom will match a brown sofa at home, all want to understand color, and to tame it. Color is a beast.

We hope this book will help you begin to grasp what color is, how to work with it, how to appreciate its beauty and complexity. By learning about the science of color, we can all bring greater depth, insight, and joy to our work, no matter what discipline we're in. Even if you're just a lover of color who enjoys the spectacle of fall foliage, the visual world becomes full of wonder and far more interesting when you have the science under your belt.

2 | Why Do We See Color?

■ Color vision helps us distinguish one thing from another to better navigate the world. In addition, being able to distinguish the color of an object clues us in to the internal state of that object. The color of a tomato tells us if it is ripe. The flushed skin of a child tells us if she has a fever. Wear the wrong color to a sporting event, and you may get your face rearranged. Wear an orange safety vest, or you may end up with a back full of buckshot.

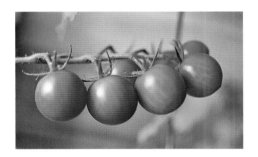

While we don't know for certain why humans developed the color vision we have, most scientists studying the matter agree that being able to pick out ripe fruit against a green background is one likely explanation for improved color vision in primates.

Most of us are no longer picking our own fruit. Instead, we're grabbing for our favorite flavor of food or drink inside the fridge. Colored containers make it so that we don't even need to read the label to know whether we've picked peach or pineapple—the color tells the story for us.

■ As primates evolved, so did their visual systems and their ability to distinguish colors. Approximately thirty million years ago, the primate ancestors of all Old World monkeys, apes, and humans began to develop the kind of keen color vision that humans have today.

■ Along with shape, texture, movement, darkness or lightness, the more colors we could see, the more information we could interpret in the light-filled world around us. Presented with two bowls of guacamole that look exactly alike except for one is bright green and the other is all brown, which would you choose? Thanks to your color vision, you've saved yourself from a nauseating night or maybe even a trip to the ER. Drive down the road and come to a stoplight, what do you do? If you could only see shades of gray, it would take you a lot longer to determine whether to stop, slow down, or go. Searching for a blind date in a crowd of people? Knowing you're on the lookout for a redhead in a turquoise shirt might lead you to the love of your life. Our world is mapped out by color, preventing five-car pileups, surging electrical currents, and getting on the wrong subway. Color can get you killed or save your life.

PRS 3562-0825-33

Medicap RD™
(capolitrium time-release capsules)

0.5 mg

ONCE-DAILY

Swallow capsule whole.
Do not cut, crush, or chew.

20 Capsules

PRS 3562-0845-33

Medicap RD™
(capolitrium time-release capsules)

1 mg

ONCE-DAILY

Swallow capsule whole.
Do not cut, crush, or chew.

20 Capsules

PRS 3562-0865-33

Medicap RD™
(capolitrium time-release capsules)

5 mg

ONCE-DAILY

Swallow capsule whole.
Do not cut, crush, or chew.

20 Capsules

Color vision is tied to survival. Today, it's not just about accidentally eating a poisonous berry; it's about avoiding hazards like taking the wrong medication. Colors of bottles, tops, labels, and even the pills, themselves, help us distinguish between medications and dosages.

Color coding often warns us of danger. Whether it be a country under a red-alert terror code or an instruction with a red exclamation point, we use color to point out when there's a risk of injury or damage. In the case of jumper cables, connecting the cables to the wrong terminals can ruin the car battery and sometimes even the electrical system. By the simple coding of red to red and black to black, most people can jump their cars without calling AAA.

One of the most recognizable forms of information via color is the traffic light. It prevents car crashes, pedestrian accidents, and the general chaos that occurs if you don't know when to stop and when to go.

Team colors represent so much more than just the uniforms on players' backs. They help identify a geographical area, a fellow fan, an ethos, even a way of life. The tribal nature of team colors isn't a coincidence. Tribes of all kinds have used color for millennia to simultaneously affiliate and differentiate themselves.

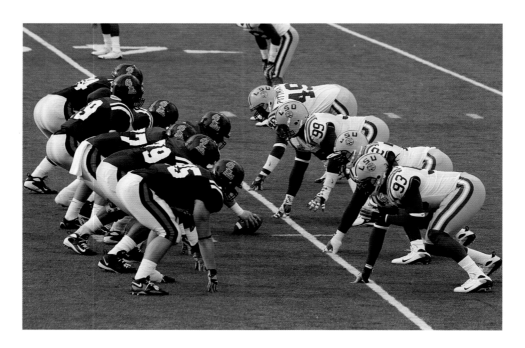

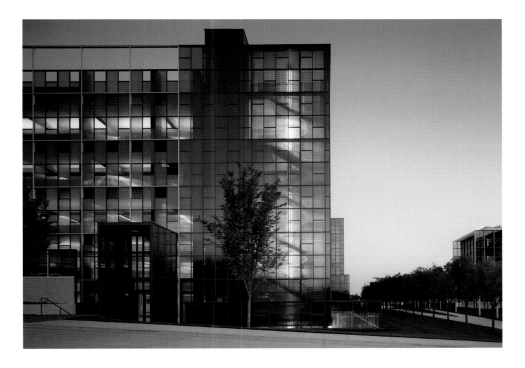

Finding your seat in a stadium (below) can be confusing and time-consuming. Color coding moves you in the right direction, onto the right floor, or over to the proper section. The garage above and to the right, designed by Rand Elliott, uses a combination of colored lighting and materials to distinguish between levels and make it easier to find your car.

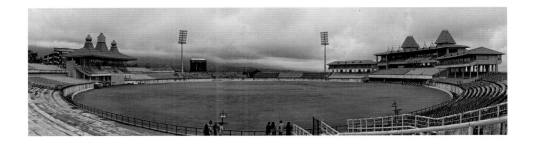

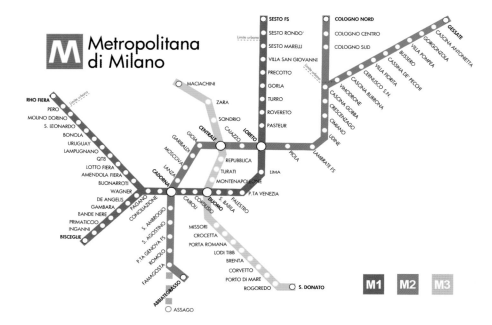

Maps of all kinds use color to speed comprehension. In this case, are you on the right subway line? Different route colors are often used not only in transit maps, but also in signage, on the trains themselves, and sometimes even as line names (the red line, the green line). If all the routes on this map were one color, you would still be able to distinguish them, but you might miss your train in the process.

As information moves farther from nature and onto screens, color mapping often comes in the form of graphics. Venn diagrams, pie charts, and every imaginable infographic found in your average PowerPoint presentation use color to show where ideas separate and converge.

WHY DO WE SEE COLOR?

3 | How Is Color Related to Light?

■ Without light, there is no color. But the relationship between light and color is often baffling and counterintuitive. Light is a physical entity in our universe. Color is constructed by a brain, and the colors that are actually perceived depend on whose brain is constructing them.

■ Human brains perceive just a narrow band of light, and yet most of us are able to construct a world of abundant color. Our wondrous visual system relies on the physical properties of light and the molecular properties of seen objects to create our color sense.

■ For most of human existence, the sun has been the source of light that makes our world colorful. Though we humans generally perceive sunlight to be white or golden, it is actually made up of all the colors we see in a rainbow. These colors contained within sunlight are what enable us to see color in tangible things—from bananas to birds to buildings and beyond.

4 | How Do We Know That Sunlight Is Made Up of Many Colors?

■ The complex makeup of white light was first systematically studied by Isaac Newton in 1672. He made a hole in a wood shutter for a beam of white sunlight to pass through. He then put a prism in the path of the white light. He saw that the prism broke up the white light into a rainbow. His conclusion: White light isn't white after all.

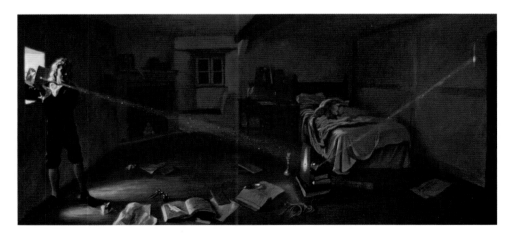

An artist's rendition of Newton's experiment.

■ Newton also realized that each of these colors must have individual properties because in addition to their color differences, they exited the prism at different angles.

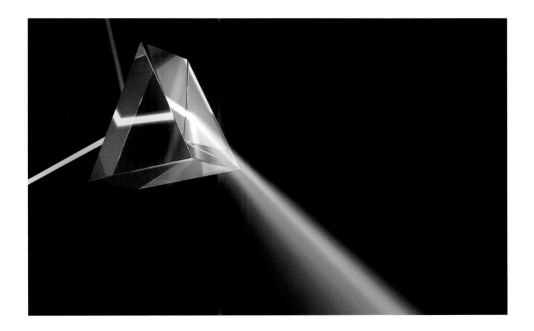

For centuries, scientists and philosophers had struggled with the question: Is color a property of objects? Are the petals of a red rose in and of themselves red? It's a question that most people today would still answer with a definitive *YES!* However, Newton produced hard evidence to show that something more complicated is going on: Light plays a role in the colors we see. What Newton did not yet understand was the role our brains play in the perception of color.

You can see a beam of white light enter this prism and then fan out into the colors of the rainbow as it exits.

Newton's original color wheel.

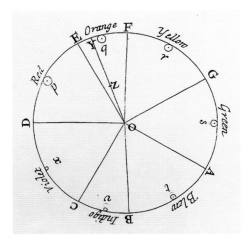

5 | What Is ROYGBIV?

■ Newton separated the colored light that he saw exit the prism into seven colors: red, orange, yellow, green, blue, indigo, and violet. A mnemonic was invented to help remember these colors: ROYGBIV.

■ Red, orange, yellow, green, blue, indigo, and violet are not the actual colors of a rainbow but rather a series of artificial categories created by Newton. He chose seven colors because he wanted the visible spectrum to parallel the number of notes in a musical scale. Due to the continuous transitions between colors of the rainbow, he just as easily could've chosen three colors, five colors, ten colors, twenty colors, or more.

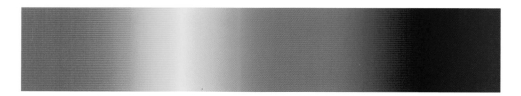

The spectrum of color that Newton saw emerging from his prism.

That spectrum divided into the seven colors Newton chose.
He could have sliced and diced in any way.

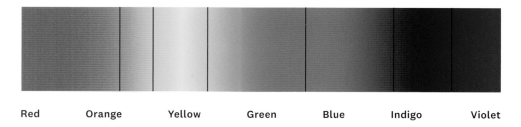

Red　　　Orange　　　Yellow　　　Green　　　Blue　　　Indigo　　　Violet

■ The colors we now name in the rainbow differ from Newton's because we have removed indigo, showing just how arbitrary his choice of red, orange, yellow, green, blue, indigo, and violet was. In this book, when we refer to the colors of light, we will follow modern convention and list six colors instead of Newton's seven: red, orange, yellow, green, blue, and violet.

Which color was "blue" to Newton?

The one on the left.
Newton called the one on the right "indigo."
Both colors now simply fall under the category of "blue."

6 | What Are Spectral Colors?

■ The colors we see when a beam of sunlight exits a prism are referred to as spectral colors. These are the colors we see in a rainbow in the sky.

■ Spectral colors are pure colors, meaning if you pass one of these colors through a prism, it will not separate into more than one color. Though there appear to be seemingly few colors in the visible spectrum, there are actually infinitely many, just as there are infinitely many numbers between one and ten. It's our brains that are not capable of perceiving the minute gradations between them.

■ Though we think of oranges, greens, and violets as colors that are mixed, this is only partly true. When talking about light, pure versions of oranges and greens also exist. There are only pure violets, though, which are distinct from purples. We'll get to purples soon. Like violets, spectral oranges and greens can be passed through a prism and will not separate into more than one color. Perhaps most surprisingly, yellow can be made from a mixture of colored lights. Spectral colors only apply to *light* and not tangible things.

We might caption this image as showing "spectral colors," but a printed photograph of spectral colors doesn't actually show spectral colors at all. Spectral colors refer to colors of light, not colors of ink.

7 | How Is Wavelength Related to Color?

■ At the turn of the nineteenth century, Thomas Young, another English scientist, was able to demonstrate what other scientists had hypothesized: that light—like sound—is a wave. The color of a particular light wave is determined by its wavelength (measured from the peak of one wave to the peak of the next wave) or frequency (the number of waves per second). Wavelength varies inversely with frequency. A color is typically referred to *only* by its wavelength.

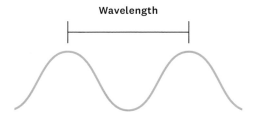

Wavelength is measured from the top of one wave to the top of the next.

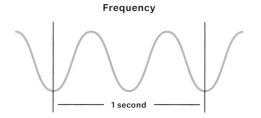

Frequency is measured by counting how many waves pass a particular point per second.

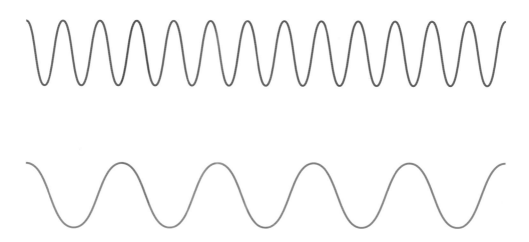

Here are two waves, traveling in the same direction, that pass through the same points in the same amount of time. The wave on top is a higher frequency wave because there are more waves per second. The wave on the bottom is a lower frequency wave because there are fewer waves per second. As you can see, the wavelength of the lower frequency wave is longer.

For visible light, different ranges of wavelengths and their corresponding frequencies are grouped into categories that have been named red, orange, yellow, green, blue, and violet. The category we call violet is made up of the shortest wavelengths from approximately 380 to 450 nm (or nanometers, which are one-billionth of a meter). On the other hand, violet has the highest frequency from approximately 666 to 789 THz (or terahertz, which are one trillion cycles per second). Conversely, the category we call red is made of the longest wavelengths, from approximately 620 to 740 nanometers, but the lowest frequency, from approximately 483 to 405 THz.

■ All the colors in a rainbow blend fluidly from one category to the next; each individual color has a different wavelength, depending on where it sits on the continuum of red to violet. But these ranges in wavelength are only approximations because where one color begins and another ends is subjective to whichever brain is viewing them.

In 1905, Albert Einstein was able to explain why light has the qualities of both waves and particles. This phenomenon is known as the wave-particle duality. Particles of light are called photons, and they travel in a wavelike manner.

8 | What Is the Visible Spectrum?

■ The range of light from red to violet in a rainbow that is visible to the *human* eye is called the visible spectrum. Please take note of the emphasis on *human*! The visible spectrum is a tiny portion of something much larger: the electromagnetic spectrum. The only reason we have a special name for the visible part is because our particular anatomy is responsive to these particular wavelengths of light.

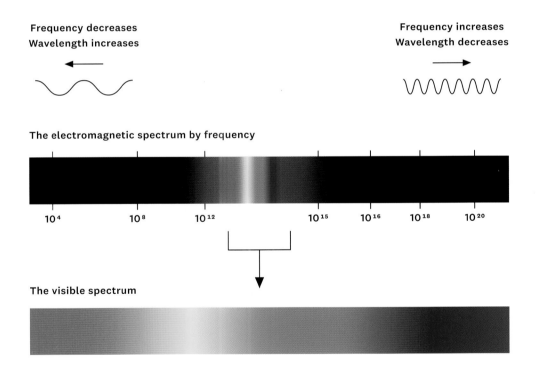

Frequency decreases
Wavelength increases

Frequency increases
Wavelength decreases

The electromagnetic spectrum by frequency

10^4 10^8 10^{12} 10^{15} 10^{16} 10^{18} 10^{20}

The visible spectrum

The range of visible light is just one part of the
much larger visible spectrum.

At one end of the electromagnetic spectrum, beyond red light with its longer wavelengths and lower frequencies, are even longer wavelengths and even lower frequencies of light that include infrared, microwaves, and radio waves. At the other end, beyond violet light with its shorter wavelengths of light and higher frequencies, there are even shorter wavelengths of light with even higher frequencies that include ultraviolet (UV) rays, X-rays, and gamma rays. Just as the borders between colors are fuzzy and arbitrary, so are the borders between these other parts of the electromagnetic spectrum. X-ray is just another "color," like orange, in that it encompasses a range of wavelengths of light. It's just that we humans can't see this color.

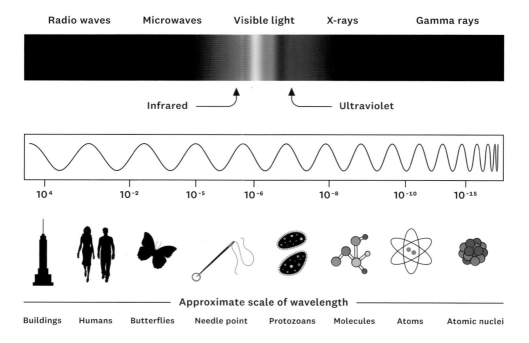

Wavelengths in the chart above are given in meters. The relative sizes of wavelengths across the electromagnetic spectrum are difficult to imagine. The icons show the approximate sizes of wavelengths ranging from 10^4 to 10^{-15} in meters, via real world examples.

It's important to note that the visible spectrum as it is typically illustrated does not contain all the variations of colors that humans can see; rather, the spectrum is used to represent only the pure spectral colors made up of individual wavelengths of light. The bulk of the colors we see every day are actually made up of a mixture of wavelengths of light.

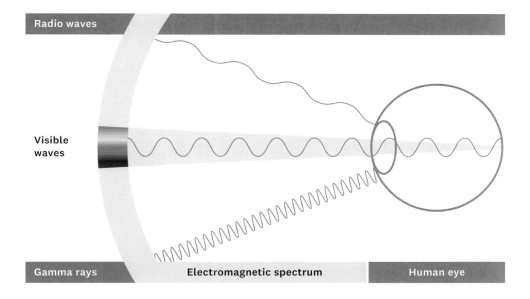

Radio waves

Visible
waves

Gamma rays Electromagnetic spectrum Human eye

Only wavelengths of light in the
visual spectrum are sensed by
the human eye.

9 | How Is Energy Related to Color?

■ Visible light, like all parts of the electromagnetic spectrum, is a form of energy. And each color we see is associated with a different energy level, with higher frequencies of light having higher energy levels. Blue and violet light have the highest energy and red the lowest.

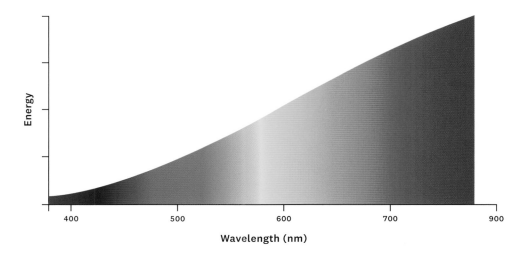

This graph, called a spectral power distribution diagram, shows how much light each wavelength produces for an incandescent light bulb, although such a diagram can be created for any light source. The spectral power of an incandescent bulb is weighted heavily to the red side of the visible spectrum. When electricity runs through the filament in an incandescent bulb, it heats it up. Only a small percentage of the energy that runs through the filament is emitted as light—specifically low-energy light, since most of the energy is lost to heat. Low-energy light is at the red end of the spectrum, which is why incandescent bulbs give off an orangy-yellow glow.

Waves of light, like all waves, transfer energy from one place to another. This transfer is responsible for the colors we see all around us. When light hits the surface of an object, some of the light is absorbed and some is reflected. The energy of the light that is absorbed goes into increasing the temperature of the object, and the energy that is reflected is what we see as color. Which wavelengths are reflected is determined by the molecular structure of the surface of the object.

Why are most plants green? Chloroplasts, the part of a plant's cell pictured right, absorb red, orange, some yellow, blue, and violet wavelengths of visible light and reflect green and some yellow wavelengths. They use the energy of the non-green wavelengths for photosynthesis. Red, orange, some yellow, blue, and violet wavelengths of light are responsible for a plant's ability to grow. In one of nature's great ironies, green wavelengths of light are useless to the greenery we see around us.

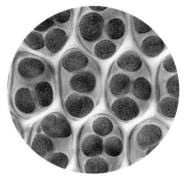

■ Think about the sun beaming down on a blue car. Part of the energy contained in light hitting the car will heat up the car, and part of the energy will be reflected in the form of light that we perceive as blue. Specifically, the medium and longer wavelengths of visible light that do not appear blue will be absorbed by the surface of the car and those shorter wavelengths of visible light that do appear blue will be reflected.

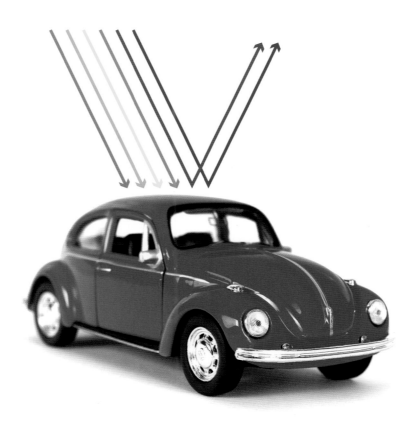

10 | How Does Light Turn Into Color?

■ The process of light turning into color can be broken down broadly into four steps. First, there's a spectrum of light emitted from a source—the sun, a fluorescent bulb, fire, and so forth. Second, that light strikes an object, material, or surface. Some of this light is absorbed and some of it is reflected, usually in the form of multiple wavelengths of light. Third, some of those wavelengths of light will be detected by our visual system. Fourth, there's the psychology of perception, where the mechanics of our particular brains determine which colors we actually perceive—a process that goes beyond just the physical nature of these wavelengths.

■ Although the steps might sound simple, the process itself is anything but. Step four is where things get tricky. We take in a whopping amount of information and try to make the best sense of it, all while not becoming overwhelmed. Our visual system uses a whole host of cues to help us determine the colors we see. The light reflected at us from a particular point is just one of these cues. As we try to make sense of the objects in front of us, we have to construct their shapes, the light source that is illuminating them, the wider visual field in which they sit, and, yes, the color that fills their boundaries.

Three of the four steps that lead to our color perception as they are typically graphed in the world of vision science are shown below.

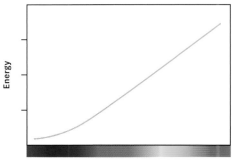

Illumination

This graph shows how much light is produced by each wavelength of the light source, or what's called the spectral power distribution.

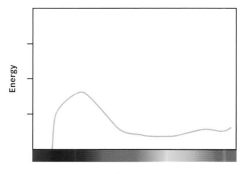

Reflectance

This graph shows what light is reflected after the light hits the object, called the surface-reflectance function.

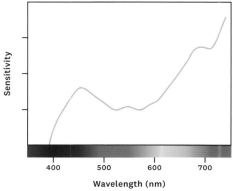

Color signal

The combination of the two functions above generates a color signal. This graph shows how that color signal is actually perceived, based on what wavelengths of light the human eye is most sensitive to.

Wavelength (nm)

When we get to the fourth step, sometimes our perception gets wonky. The blue star below appears as four intersecting lines, but the blue star with the extended black lines fills into a blue circle when you stare at it. There is no difference between the two blue stars. They're both just four intersecting lines. Nevertheless, psychologists Christoph Redies and Lothar Spillman discovered that when the extended black lines are added, the human brain sees a circle, where a spectrophotometer (an instrument that measures light according to wavelength) does not.

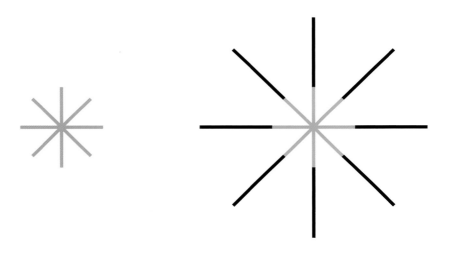

■ Our brains work miraculously in yet one more way: They not only take in the information at the current moment, but also take what we've learned from the past, helping us to navigate the present and future.

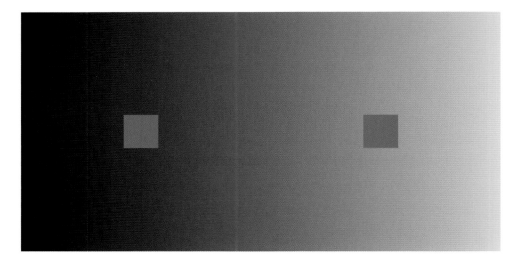

Both gray squares are exactly the same color, but we perceive them as different due to the changing background color. The darker the background, the lighter the square appears. The lighter the background, the darker the square appears. The human brain is not simply a light-measuring device. The perception of color is far more complicated and surprising.

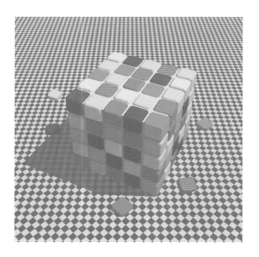 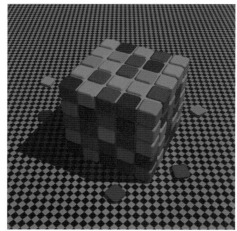

Take a look at the blue squares on the top of the left cube in this visual experiment by neuro-scientists Dale Purves and Beau Lotto. Now take a look at the yellow squares on the top of the right cube. Here's what is crazy: They're both the same color, and that color is gray! If you don't trust us, you can make a color copy of this page, cut out the squares and see for yourself.

HOW DOES LIGHT TURN INTO COLOR?

11 | How Does Our Visual System Adjust to Changes in Light?

■ Millions of changes in light happen from daybreak to twilight, but thankfully we don't experience these changes moment by moment. Most of the countless changes in light that happen around us as we move through the world are not necessary for us to perceive. Instead we take in only what is useful and ignore the rest.

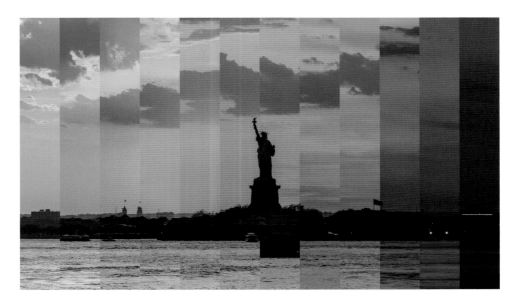

This time-slice photo takes place over a relatively small period of time.
However, it gives us a sense of just how many changes in light we adjust to every day.

Imagine if we smelled every smell around us, or heard every sound no matter how small. If we perceived all of these stimuli, we would become overwhelmed. Instead, our brains do the work of culling enough information so that we are able to function successfully and safely, but not so much that we become overwhelmed or paralyzed. The same is true for light and color. Our visual system is constantly taking in information based on the light in our environment. It then adapts to that environment without bombarding us with too much information.

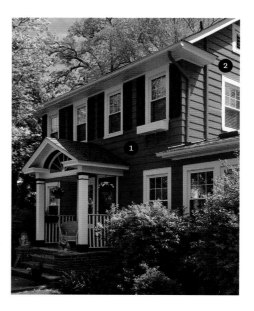

The human brain has no trouble seeing this house as "red." But the colors of the front and side appear very different when isolated.

The changes in light that we do perceive clue us in to how to construct a navigable world for ourselves. We generally attribute gradual changes in color or brightness to a change in illumination. A shadow on a floor, a patch of light across a wall, a plant half in shade, half in sun—not one of these changes in light disturbs our notion that we're looking at one object. Conversely, we generally attribute abrupt changes in color or brightness to a change in surface—we see a red plate as a separate object from the gray table it sits on; we don't see a tabletop that shifts from red to gray.

12 | Why Are Borders and Edges Key to Our Color Vision?

■ Our visual system doesn't just sense wavelengths of light. Without even noticing, we search for patterns and differences in light that lead us to deduce that one object is separate from the next. Borders and edges are especially key to helping us understand where one object ends and another begins.

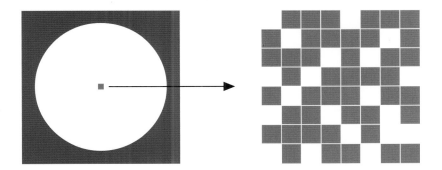

Imagine trying to create a graphic, pixel by pixel. Something as simple as a red circle on a blue background could take days, and the size of the file would be massive. That's why computer programs like Photoshop have what's called a "fill" function to make it easy to place color within an area that has clear borders. For example, after you draw the outline of a circle, the entire circle can be filled with one click to pick a color and another to "pour" it, while the file size is kept at a minimum. The human brain has an equivalent of a fill function. When it identifies borders or edges of an object, our brains fill the color in between—even though, point by point, the color may actually change across the surface. The red house on the opposite page is a great example. Despite the range in colors of red (due to where the light falls), the house is perceived as one color. The borders of the structure inform us that this is one object, and hence "one" color. The brain gets the information it needs without using up too many resources.

Most individual objects have multiple changes in light across their surfaces that produce what appear to be multiple colors. However, we don't see the changes in light as breaking up the object into parts. Thanks to their borders and edges, we perceive these objects to be whole. Borders and edges also help us see two different objects even if their colors are the same. We can see that a white cup is a separate object from the white counter it sits on. There is a change in contrast where the edge of the cup meets the counter because of how the light hits each. Contrasting borders or edges give us the most information about where one object ends and another begins—even more than color itself.

Our visual system has developed over time to identify borders and edges with mastery. Seeing color is merely an aid to this function. Identifying borders and edges is far more efficient than having to identify the individual colors at every point on a surface. In fact, without borders and edges, our color vision doesn't work. We fail to see color at all without something that falls outside the edges to compare it to. Even the most intense color will fade to gray if you block out the colors that surround it. Try it and you'll see!

Take a white piece of paper and roll it into a tube. Find a surface or piece of paper with a solid bright block of color. Then place one end of the tube an inch above the surface. Put your eye up to the top of the tube so that you can't see anything else except the patch of color at the bottom of the tube. Stare at the patch of color for one to two minutes. Watch it disappear.

13 | What Does the Retina Do?

■ When light hits our eyes, it stimulates a part of our brain called the retina. It is in the retina where color perception starts. Just a thin three layers of cells about the thickness of a credit card at the back of the eye, the retina is actually made up of brain tissue that separates from the brain during the development of the fetus, but remains connected to the brain via the optic nerve.

■ The retina performs the first, most important step in visual information processing in that it responds to the light that hits our eyes and turns that light into neural signals that the brain can understand. Inside the retina there are a number of different kinds of photoreceptor cells. The retina processes the signals produced by its photoreceptor cells and sends them to the rest of the brain via the optic nerve. The eventual result is a world of color during the day and shades of gray at night.

■ It's not just wavelengths of light that our retina responds to in order to help us visualize the world around us. Our retina also responds to how light or dark a surface appears. This part of our visual system is more primitive than the part that analyzes color and can operate independently of or jointly with the retinal cells that respond to wavelengths of light. It helps us perceive small changes or discontinuities in light to help us define the boundaries of objects compared to their backgrounds. Color-blind yet critical, it answers the first and foremost question when it comes to our survival: Is there anything there?

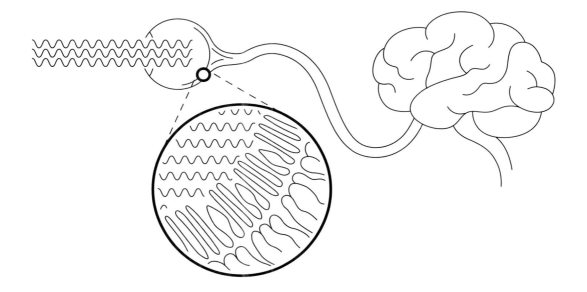

The highlighted circle shows a small piece of the retina, which is represented by the curved line hugging the back of the eye. The retina feeds information via the optic nerve into areas of the brain that process images.

14 | What Are Rods?

■ Rods are the photoreceptor cells in our retina that allow us to see in dim light and the dark. We only have one type of rod, but there are approximately one hundred twenty million of them within each of our retinas.

■ Rods dominate when there is very little light available—at night or in a dark room when little to no color is visible and we see mostly black, white, and grays. Rods are efficient and amazing light collectors. They are highly sensitive to small amounts of light and to changes in light; so sensitive that even just one photon (the smallest unit of light) can be detected. Your eye detecting one photon is like feeling one microscopic speck of dust land on your skin.

■ Rods don't allow for much acuity when we look at something in low light. Although rods can help us distinguish small shifts in light, we can't clearly see what the light is illuminating. Rods are also especially built to see movement in the periphery of our vision, but they won't be able to help detect what's moving or what color it is.

Rods are the tall, thin, highlighted cells.

15 | What Are Cones?

■ Cones are the photoreceptor cells in our retinas that are central to our color vision. Despite the fact that there are three different types of cones versus only one type of rod, there are far fewer cones than rods, with only one cone to approximately every twenty rods.

■ Unlike rods, cones dominate in the daytime or in bright light. They also differ from rods in that they allow for high acuity in our vision but are not sensitive to small shifts in light. Contrary to what you might think, cones on their own do not tell us what colors we are seeing. The signals from the cones are processed further by the retina and then transmitted to the rest of our brain, which eventually translates them into the perception of color.

■ Cones are divided into three types: L cones, which are sensitive to longer wavelengths of light within the visible spectrum; M cones, which are sensitive to medium wavelengths of light within the visible spectrum; and S cones, which are sensitive to shorter wavelengths of light within the visible spectrum. These three cones are sometimes referred to as red, green, and blue cones, respectively, signaling which cones help us see which colors. Just a word of warning: Never refer to cones by color name in front of a vision scientist unless you enjoy a good dressing-down. We will be referring to cones by wavelength type, not color, except in cases where it makes it harder to understand the concept being explained.

Cones are the shorter cells sandwiched between rods.

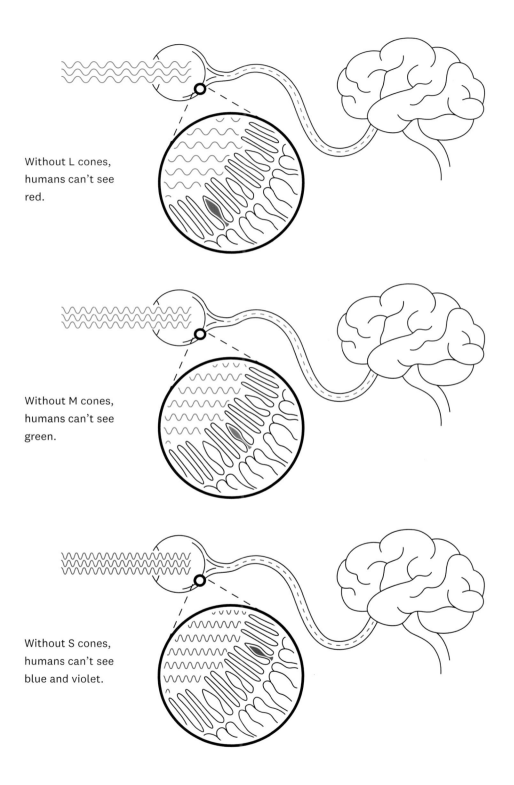

Without L cones, humans can't see red.

Without M cones, humans can't see green.

Without S cones, humans can't see blue and violet.

16 | What Is Trichromacy?

■ Because humans have three kinds of cones in our retinas, we are called trichromats. These three cone types carry information that allows us to see the range of colors across the visible spectrum and the different combinations of spectral colors that make up the world around us.

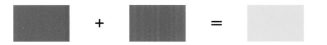

Mix red and blue light, and we see magenta.

Mix blue and green light, and we see cyan.

Mix red and green light, and we see yellow.

A full color wheel emerges.

Some mixtures of light are more surprising than others. Take the color yellow, which emerges when we combine red and green light. The theater lights to the left illustrate this nonspectral yellow where the red and green lights overlap.

■ Our cones are not equally sensitive to all the colors in the visible spectrum. In fact, cones have peak sensitivity only in narrow bands of the spectrum. But the information they pass on enables us to see the millions of colors around us due to our brain's ability to compare the activity in each type of cone cell. You might think that when red light hits our retina, for example, the cones that are sensitive to longer wavelengths of light (our L cones) would be activated and signal our brains to see red. But this is not how it happens. All three cone types are active simultaneously. Our visual system compares the activity in all three cone types and adds up the outputs of each to find out where the greatest activity is taking place. Flying in the face of logic, when there are equal amounts of activity in all three cones, we see white light.

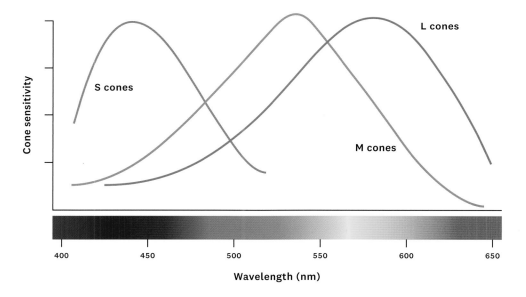

L cones are sometimes called "red cones." However, this is a misnomer because they are most sensitive to yellow light, not red. In fact, their sensitivity is very close to our M cones, which are also most sensitive to yellow and yellow-green light. However, if the human brain senses more activity in our L cones than in our M cones, we see red because L cones are sensitive to longer wavelengths of light that appear red.

WHAT IS TRICHROMACY?

■ This ability to compare cone activity is what allows us to see colors that our cones are not particularly sensitive to. Our L cones are actually most sensitive to yellow light, not red light. And yet they are what help us to see red. When the L cones are more active than the M and S cones, our visual system uses this information and then further interprets it, which results in the perception of red even though the L cones' sensitivity greatly diminishes the farther the light moves into the redder end of the spectrum.

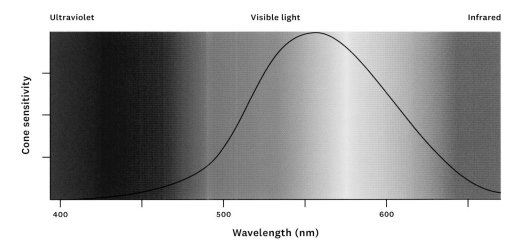

The span of yellow light in the visible spectrum is miniscule yet it warrants its own name. This seemingly strange decision isn't at all arbitrary. It's precisely because our peak sensitivity overall is to yellow and greenish-yellow light. Between 580 and 585 nms, we can distinguish numerous changes in color, but when it comes to blues between 420 and 440 nms, they all look the same. On the other end of the spectrum, reds between 640 and 660 nms will also be indistinguishable.

17 | What Is Color Opponency?

■ Conjuring up a blue-green is intuitive. But try to imagine a red-green. Color pairings like red-green don't make sense, and the quest to find out why led to the theory of color opponency. The theory goes like this: There are four colors that humans, independent of language or culture, perceive as pure, that is, we can't identify tinges of other colors in these pure colors. The four colors are red, green, blue, and yellow. These fundamental colors seemed to naturally fall into two sets of opponent pairs: red/green and blue/yellow. While we can imagine a reddish-blue or a greenish-yellow, we can't imagine a red-green or a blue-yellow.

■ The theory of color opponency was first conceived as an alternative to the theory of trichromatic color vision. The important thing to note here is that both are just that—theories! We don't yet know for sure how color vision works. However, both theories are now generally thought of as compatible. Currently, there is evidence to support the idea that specific neurons combine the signals from each individual cone type, which then results in the experience of red, green, blue, or yellow (or any other color of the rainbow). The opponent pairs that these colors form are referred to as channels, with each color of a pair at opposite ends of a single axis. If the calculations by our visual system cause the red-green channel or the blue-yellow channel to balance each other out, we don't see color at all—instead we see white light. The fact that we don't see color when a channel is balanced is why we can't imagine what a red-green or blue-yellow would look like. These colors simply don't exist for our visual system. Only when the channels are imbalanced do we see color.

■ There are two more fundamental colors that form a third opponency channel: black and white. This opponent channel has a slightly different function: To compare dark versus light, which helps us, among other things, define where edges are formed and where one object begins and another ends.

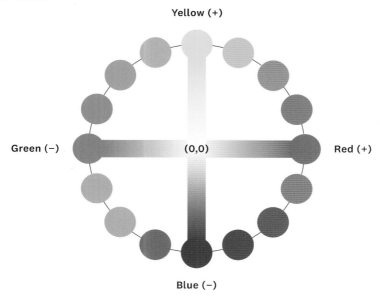

Ewald Hering, a professor of physiology in Germany, developed the theory of color opponency in the last quarter of the nineteenth century. Hering claimed that red and green were opponent colors that could be represented along a single axis. Positive values on the axis are reddish, negative values are greenish, and zero—or an equal balance between the two—represents white. Hering named a second opponent pair, yellow and blue, which are also represented on a single axis. Positive values on this axis are yellowish and negative values are bluish. Zero, once again, represents an equal balance, which appears white. Any hue can be represented by two coordinate values, one on each axis. Orange, a color with both redness and yellowness, has a positive value on both axes; turquoise, a color with both greenness and blueness, has a negative value on both axes. White has zero on both axes because it is void of redness, greenness, yellowness, or blueness. One note: If it seems strange that red and green light mix to become yellow light (see p. 51), but red and green cancel each other out according to color opponent theory, you will have hit on one of the numerous examples of where scientific ideas and seeming reality will cause you to want to bang your head against a wall.

18 | What Is an Afterimage?

■ When you stare at a magenta dress and then look from the magenta dress to a white wall, you will see the shape of the dress moving with your eyes. But its color will have bizarrely changed from magenta to yellow-green. This phenomenon is called an afterimage and philosophers and scientists had a hard time making sense of what could be causing this strange shift.

Stare at the black dot in the center for thirty seconds, and then switch your gaze to the dot on the opposite page. The magenta turns to yellow-green.

When one cone type is activated more strongly than the other two by incoming light, it eventually tires. If you're looking at a colored light, your three types of cones will change their sensitivity roughly in proportion to how strongly they absorb the light. For example, in response to an orange-red light, the long-wave sensitive cones will change their sensitivity most, followed by the middle-wave sensitive cones, and then the short-wave sensitive cones. If, after looking at the orange-red light for a prolonged amount of time, you then look at a white screen (which should evoke equal responses from all three cone types), your cones' responses will at first be unequal because your now tired long-wave sensitive cones will have to adjust most to the new light. The result will be that you see a blue-green image—the composite of the other two cone types (blue and green).

●

■ Afterimages are one of the best examples of how our color vision is far from straightforward. They alone can cause us to see things that aren't there or change a color to its opposite. The mysteries of afterimages hint at so many of the other mysteries of color vision.

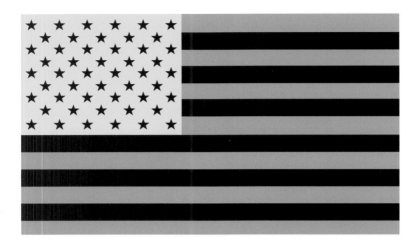

Stare at this cyan, black, and yellow flag for thirty seconds. Move your gaze to the white space below the flag. A classic American flag will appear.

Stare at the negative of any photo. Shift your gaze
to white space, and the photo in its true colors will appear.

19 | What Is Color Constancy?

■ When you don brown-tinted sunglasses, the world doesn't suddenly appear brown. White still appears white, red appears red, green appears green, and so forth. Our visual system's amazing ability to identify a color under different lighting conditions or when there are changes in lighting is called color constancy.

Check out the yellow tulips in the unfiltered photo to the right.

Despite the addition of a colored filter, the yellow tulips are still easy to identify in the second photo, above left. The green tulips in the third photo (above right) are just the "yellow" tulips from the second photo, cut and pasted into the photo without the filter. However, they appear green because the lighting has changed in only that one part of the photograph.

We can identify a category of color, like green, under different conditions, whether in bright sunlight, in a room lit by fluorescents, or in a dark room with only a low-watt incandescent light bulb. By the same token, when looking at a wall painted a certain color, even if part of it is in shadow and another part is brightly lit, we still recognize the wall's color as one shade. But if you took a picture of a bright green object first in low light and then in daylight, and put these pictures side by side under the same lighting conditions, the one in low light would look much darker because your brain is now comparing it to the green in bright lighting.

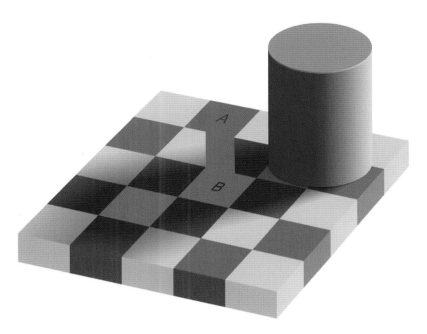

Look at square A. It appears to be one of the black checkerboard squares. Look at square B. It appears to be one of the white checkerboard squares. Now look at the channel connecting them. They will both appear to be exactly the same color: gray. Vision scientist Edward Adelson came up with this optical illusion to show how light and shadow can trick the human brain. Square A appears black because it is on the part of the checkerboard that is in the light. Square B appears white because it is on the part of the checkerboard that is in shadow. The eye compensates for these light changes and adjusts the gray accordingly.

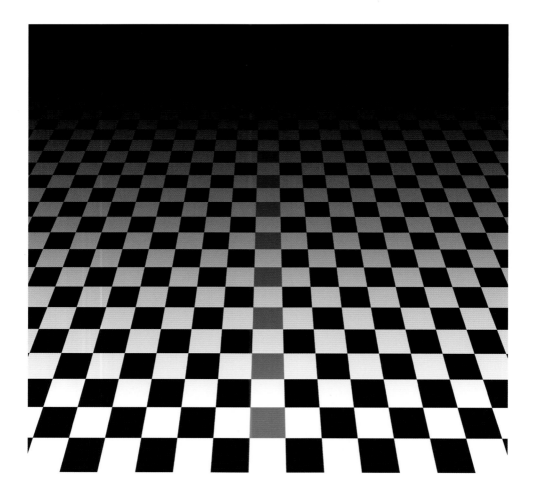

This checkerboard, created by artist David Briggs, features a red path down the middle. The red appears to be the same color as it fades into oblivion. In fact, each red square is a different color. However, the brain adjusts for these color changes as the squares appear to move into shadow.

■ The purpose of color constancy is not to aid us in identifying hues but in identifying objects. We can adapt to increases or decreases in levels of light as long as the contrast between objects remains constant. The contrast is what allows us to separate one object from another.

Here's a classic experiment that reveals just how good our retinas are at adjusting to low light or bright light. Move a piece of paper with black text from indoors (as it would appear above left) to outside (as it would appear above right) and the level of illumination (the reflectance) of both the white paper and black text can change by a factor of one hundred. Measurements via a spectrophotometer reveal that the black text viewed outside is actually brighter than the white paper viewed inside, even though the black continues to look black when you go from inside to out and the white continues to look white. This extreme example of color constancy demonstrates the underlying reason for such adaptability: The human brain is not as concerned with color as it is with objects. Color serves as a way to identify objects. The amount of light an object reflects is less important than how much light an object reflects relative to other objects.

20 | What Is Simultaneous Contrast?

◼ Simultaneous contrast describes how colors seem to shift depending on what other colors they are next to. There is always an interaction and interdependence between the colors we see. Simultaneous contrast reveals something of utmost importance: Color is not a fixed entity. Color shifts show once again how color isn't constructed solely via particular wavelengths of light reflected into our eyes but by a larger visual field.

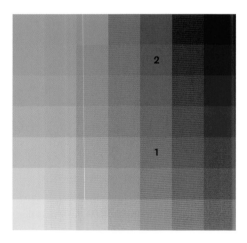

The colors in both grids are exactly the same, just rearranged. The squares marked 1 in each grid are the same color ink. So are the squares marked 2. However, the brain perceives a slight difference. Physicist and psychologist Jan Koenderink invented this color shuffle to show the effects of simultaneous contrast.

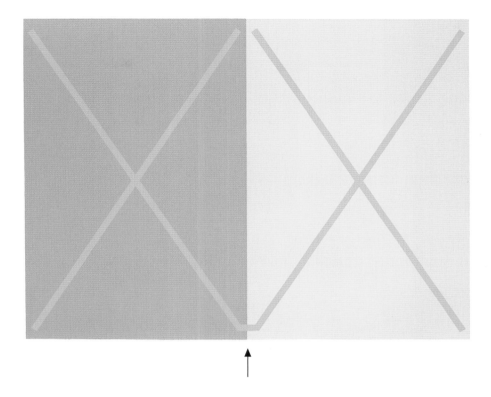

The Xs on these squares are the same color, as evidenced by the
connector between the Xs. However, the apparent color of the X
on the left-hand square is influenced by the color of the right-hand
square, and vice-versa for the X on the right-hand square.

Simultaneous contrast can make a color look more saturated, duller, darker, lighter, or some combination thereof, depending on what color or colors it sits next to. The shape of an object or surface and the orientation of the light that illuminates it can also affect the colors that we see, sometimes making two different colors appear the same or two of the same colors appear different.

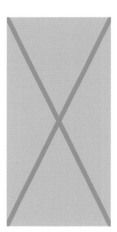

All of the Xs are printed in the same color. See how they appear to change color as they are paired with different background colors.

■ A turquoise square will appear bluer when placed on a green surface and greener when placed on a blue one. If you place it on a comparatively more saturated color, it will look duller and on a duller color, more saturated. The same square on a darker color will look lighter and on a lighter color, darker—and so on and so forth. Artists have long used these special effects of simultaneous contrast to create what appear to be shimmering fabrics or glowing sunsets, and to generally enhance or subdue the colors in their palettes.

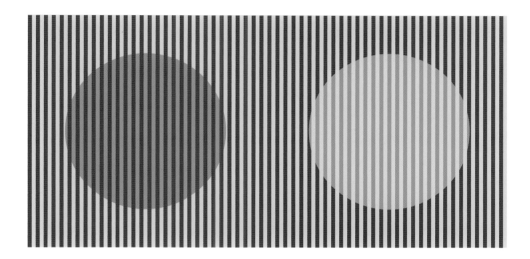

The turquoise blue in the circle on the left and the bright lime green in the circle on the right are actually the same color. Fold the page so that the colors overlap and you'll see that it's true. They appear to be completely distinct colors only because the colors they sit next to are different.

21 | Why Does the Same Color Look Different Depending on the Light Source?

■ When we change the light source illuminating an object, the object will reflect different wavelengths of light, causing the color of the object to change.

■ There are two kinds of light sources: incandescent and luminescent. Incandescent light is created by heat—for example, from the sun, fire, or tungsten lamps. Luminescent light is not heat-based and comes in the form of fluorescent lights, LEDs, monitors, and televisions, among others. Luminescent light sources only emit light from parts of the visible spectrum instead of the entire span. Depending on the kind of incandescent or luminescent light source present, the number of wavelengths reflected back from an illuminated object can be limited or expanded—changing the colors that we see.

Daylight emits light relatively evenly across the spectrum. Other kinds of incandescent light more strongly emphasize reds, oranges, and yellows; the closer you get to violet, the weaker these wavelengths of light will be. Fluorescents have a strange, uneven pattern of emission in which there are spikes in greens and green-yellows. White light LEDs are weaker when it comes to violets, blue-violets, and reds but strong in the middle of the visible spectrum. Both incandescent and luminescent light sources can emit white light—the former through full-spectrum emission and the

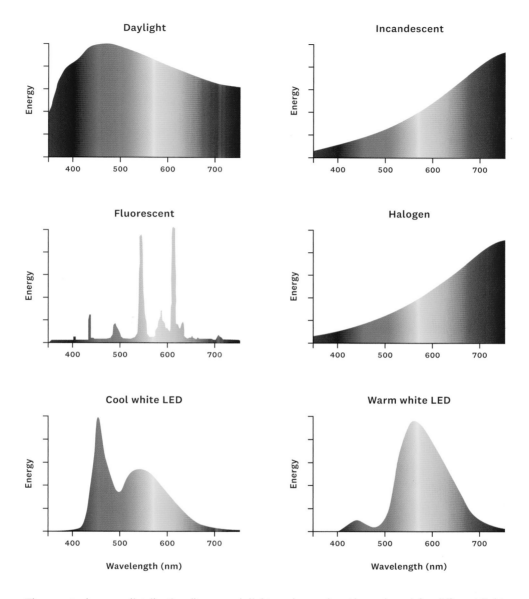

The spectral power distribution (how much light each wavelength produces) for different light sources can vary greatly. Some light sources emit the most light in the blue end of the spectrum, others in red, others somewhere in between. Some emit light smoothly across the visible spectrum; others are missing parts of the visible spectrum entirely. Here, five common household light sources are compared to daylight.

latter by mixing narrow bands of red, blue, and green light. (Remember, white light is made from equal amounts of red, green, and blue light.)

■ The light that a surface reflects is dependent on the spectrum of the light illuminating it. If an object absorbs light from a source with a wide spectrum, it will likely reflect more wavelengths. If an object absorbs light from a source that emits more light from one end of the spectrum, then more light from that end may be reflected. If an object absorbs light from a source with a limited spectrum, it may reflect fewer wavelengths.

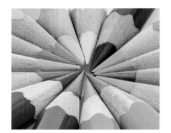

| | | |
| Incandescent | LED | Fluorescent |

The same colored pencils look different depending on the light source. The pencils under an incandescent bulb on the left have enhanced reds and a generally vibrant appearance. While you can still identify the hue of each pencil, the intensity of the colors diminishes significantly under fluorescent light.

Here we see what happens when the spectral power distribution of a light source goes from the entire visible spectrum to only one wavelength of light.

On the left, multicolored candies are photographed in daylight.

This photo shows the candies under a red and a green theater light. Remember that red and green light when mixed together create yellow light, as shown on page 51. Red and green light cover most of our visible spectrum, save for blue and violet. That's why the blue candies now appear dark green.

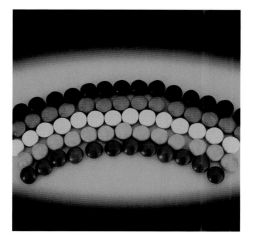

This photo is illuminated by a yellow laser with a wavelength of 589nm. Now only the yellow candies appear yellow, as there are no other wavelengths of light for the other candies to reflect.

22 | What Is Metamerism?

■ Metamerism is the term used to describe two colors that appear the same under particular lighting but aren't actually the same when measured by a spectrophotometer. These seeming matches are called metamers. Metamerism is what's at work when a shirt and a pair of blue jeans look like the same color in daylight but then appear to be different colors when you walk into your living room.

Just as we are unable to distinguish between a bag containing a five-pound weight and a bag containing two weights, one two pounds and one three pounds, so it goes with certain colors. Due to the limitations of the human visual system, we can't distinguish between certain combinations of wavelengths of light when they hit our eyes. For example, spectral yellow and yellow made up of red and green light can look the same to us.

■ Remember that our perception of a color is determined by the source of the light, by the molecular structure of the object, and the particular brain observing the object. When we change the light source illuminating an object, the wavelengths reflected may change with the new light source, as may our perception, causing the colors that matched under the first light source to no longer match.

■ With daylight, more blue wavelengths of light are reflected than red wavelengths. Incandescent bulbs are the opposite. That's why that shirt and pair of blue jeans appear to match outdoors, where blues dominate. But when you go into a room lit by incandescents, the shirt may appear purple, not blue. The red light reflected by the shirt indoors is enhanced by the incandescent bulb.

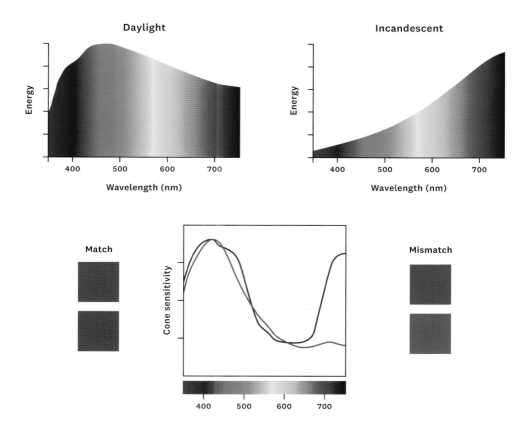

Two colors may appear the same in daylight, but not under an incandescent bulb. The reflective properties of certain blue pigments, for example, have a strong peak in the red part of the spectrum. These blues may look the same in daylight, but because incandescent light has a lot of power in the red part of the spectrum, it highlights the redness of these pigments. The result is a purple-blue, not just a blue.

23 | How Many Colors Can Humans See?

■ Those of us with normal color vision can potentially see millions of colors. The actual number all depends on the person and the context.

These tiles are part of the Farnsworth-Munsell 100 Hue Color Vision test. The test was invented to help detect color vision defects. A person with the ability to see small color gradations will line up all the tiles correctly. It's the equivalent of perfect pitch for color vision.

■ We can see the most differences between colors when they are laid out sequentially in front of us. But flash them one at a time, and it would be hard to tell the difference between two close colors. Depending on the context, it might be possible to differentiate between dozens, hundreds, thousands, tens of thousands, hundreds of thousands, and potentially millions of colors.

■ Of course, every person is different and some are more sensitive to, and thus able to perceive, more colors and changes in color. Just as some people have perfect pitch, some people have an equivalent ability with color and can identify tiny changes from one color to the next that others cannot.

Take a good look at these two colors.

When you get to the end of this book,
you're going to find one of these colored rectangles.
See if you can remember if it's the one on the left
or the one on the right.

24 | What Is Color Blindness?

■ People are color-blind when at least one cone type in their retina is abnormal or is missing. Some people are color-blind to reds and greens, others to blues and yellows, and a very small percentage of humans are only able to see shades of gray.

■ Protans are people who have abnormal or missing L cones, which are sensitive to long wavelengths of light, affecting their ability to see both reds and greens. Deutrans have abnormal or missing M cones, which are sensitive to medium wavelengths of light, also affecting their ability to see reds and greens but not in quite the same way. Tritans have abnormal or missing S cones, which are sensitive to short wavelengths of light, affecting their ability to see blues and yellows. Any of these mutations dramatically affects the number of colors a person can see.

■ The X chromosome is where the genes for our cones resides. Mutations in these genes, when passed from mother to son, are what cause most forms of color blindness. In most cases, if you're a woman, all you need is one healthy X chromosome to have normal color vision, so color blindness is much rarer in women than in men.

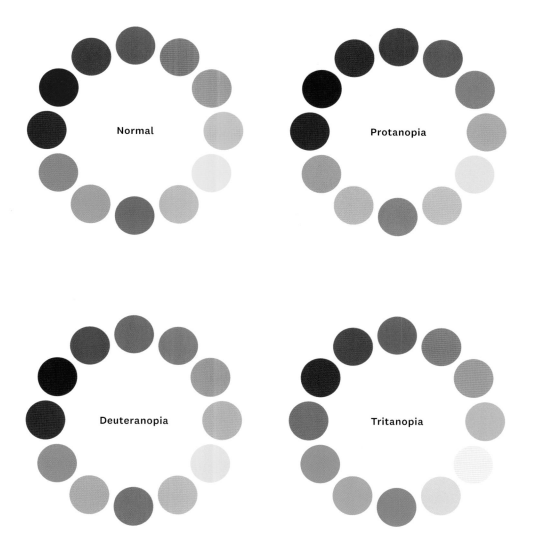

Protans and deutrans are limited to seeing blues and yellows, tritans to reds and greens. If you refer back to page 54, you'll notice that these forms of color blindness mirror the two color opponency channels—blue-yellow and red-green. When either an L cone (without which we can't see red) or an M cone (without which we can't see green) is missing or damaged, the red-green opponency channel doesn't function. When an S cone (without which we can't see blue) is missing or damaged, the blue-yellow opponency channel doesn't function.

25 | How Is Human Vision Different from the Vision of Other Animals?

◼ Other animals have different, and in certain cases, far better color vision than humans. As with humans, an animal's photoreceptor cells help determine what colors they see. Some animals are able to see light in all or in parts of the visible spectrum. Some animals are also able to see light in other parts of the electromagnetic spectrum that humans cannot.

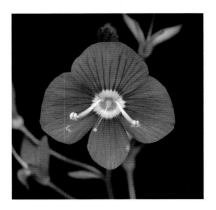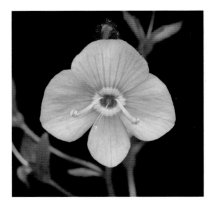

Humans see the flower *Veronica umbrosa* as it appears on the left. The visible spectrum of bees includes ultraviolet light, giving them the ability to see colors of this flower that we cannot. Scientists use what they call false color to help us understand what a bee sees. Each color is moved away from the ultraviolet part of the electromagnetic spectrum and closer to the red end of the visual spectrum to show us "colors" the bee sees that we can't. The image on the right reveals that where we see one inner circle, the bee sees two concentric circles.

Humans see the pelargonium flower as it appears on the left.
Dogs, with a visible spectrum limited to blues and yellows,
would see the flower as it appears on the right.

■ Bees are sensitive to green, blue, and ultraviolet light. Many birds, like humans, are sensitive to red, green, and blue light, but their color vision is even better than ours because they can also sense ultraviolet light. A bull's vision, like most other mammals, is comparatively more limited, and similar to humans who are color-blind to red and green. Their world is made up of yellows and blues. That bullfighter's red cape doesn't appear red to the bull at all! And for animals that are up all night, seeing color is of limited importance. For them it's a black, white, and gray world where seeing movement is more important than seeing color.

■ These different kinds of color vision have a profound effect on what animals (humans included) actually see. For example, let's take what appears to us to be a solid yellow flower. To a bee, with a visible spectrum that's less sensitive to red light than ours but sees much further into the ultraviolet wavelengths than we do, that flower might be less intense overall but have a bright interior ring that's invisible to us. The retinas of different animals are sensitive to different wavelengths of light,

depending on what they need to survive. Does the animal eat nectar or flesh? Is it an early bird or a night owl? The resulting sensitivities make for worlds colored in ways we can't even imagine. The seemingly objective color reality we hold dear turns out not to be objective at all.

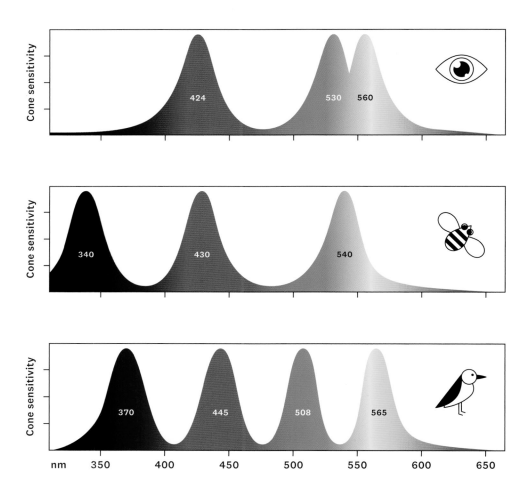

Birds' and bees' sensitivity to ultraviolet light allows them to see not just more and/or different colors, but also to see things that don't appear to exist in our world. Generally speaking, the graphs show just how different—and the same—the visible spectrums are.

26 | What Are Nonspectral Colors?

■ Up to this point, we've only been looking at the individual wavelengths of light that make up the visible spectrum. The mixing of individual wavelengths in the visible spectrum results in the visually diverse scene before us and includes the vast majority of the colors we see. These mixtures of light are called nonspectral colors.

■ Nonspectral colors include pinks, purples, dull colors, dark colors, light colors—even grays and white. A sunny yellow rose might appear to be a pure spectral color, but its hue is likely the result of a combination of wavelengths of light reflected back at your eye. These bright hues mimic pure spectral colors; but if you were to pass the light reflected by the rose through a prism, it would separate into more than one wavelength.

Nonspectral colors are too voluminous to count. Here is a tiny sampling.

27 | What Is Pigment?

■ A pigment is a material that selectively absorbs some wavelengths of light and reflects others. Pigments are everywhere—in skin, fur, feathers, petals, bark, rocks, fabric, or paint; the list goes on and on. The color of a pigment is determined by its molecular structure—the arrangement of electrons on the outside of a molecule dictates which wavelengths of light are absorbed and which wavelengths of light are reflected.

■ For most of human history, the pigments that created color in paints, inks, and dyes were made from minerals, plants, and animals. These pigments were few in number, sometimes more expensive than gold, and, a select but important few, near impossible to create. In 1856, the first synthetic dye was invented, which created the basis for other synthetic dyes. These pigments were cheap to produce, and they didn't fade. What's more, it soon became apparent that the chemical bases of these pigments efficiently absorbed light from the visible spectrum selectively, allowing scientists to create hundreds and then thousands of pigments within a decade. A new world of color was suddenly available—one that included magenta, a color that plays a major role in color printing.

Pigments have long been associated with art. That's why powders like the ones shown opposite are typically what first come to mind when speaking of pigments. Throughout history, pigments made from natural substances like iron oxide or lapis lazuli and ground into a powdered form would be mixed with a binding agent, like oil or egg, to create paint.

■ Although the vast majority of things—living and nonliving—get their color from pigments, some do not. Iridescence, the illusion of multiple colors shimmering at once, is not pigment-based. Iridescence occurs when there are ultrathin layers or microstructures which reflect or refract light off each other simultaneously. Depending on the angle of the illumination in relation to the observer, the colors shift, often creating a spectral display. Think of a hummingbird's neck, a Morpho butterfly's wings, or soap bubbles.

Chemist William Henry Perkin invented the first synthetic dye in 1856. It was called mauve. Before synthetic dyes were invented in the mid-nineteenth century, it was nearly impossible to produce purple pigments. Perkin's invention not only led to thousands of other synthetic dyes, but also to a new kind of science: modern chemistry.

28 | What Is the Difference Between Violet and Purple?

■ Violet, which is commonly thought of as a shade of purple, is a different category of color entirely. This narrow band of color is just within reach of human perception. But barely. Violet describes a range of colors composed of short wavelengths of visible light. Purple, on the other hand, describes a range of colors that are a *mixture* of long wavelengths of red light and short wavelengths of blue light.

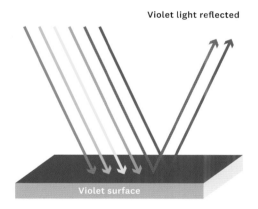

Violet light reflected

Violet surface

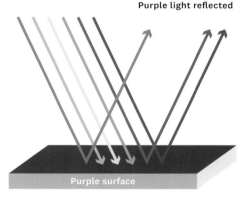

Purple light reflected

Purple surface

We see violet surfaces when red, orange, yellow, and green light is absorbed by a pigment; only blue/violet light is reflected.

We see purple surfaces when orange, yellow, and green light is absorbed, and when red and blue/violet light is reflected.

Because red and violet are at opposite ends of the visible spectrum and do not touch each other, there is no spectral gradation of color between the two—as there is between, for example, red and yellow where the wavelengths in between appear to be what we call orange. This is why purples have to be mixed from two different wavelengths, and why magenta and other purples do not appear at all within the visible spectrum, despite being visible to the human eye. However, the fact that violet and red seem to flow seamlessly into one another (as evidenced by numerous color wheels, including Newton's) is rooted in our particular visual system. Our S cones (the short wavelength cones without which we cannot see blue or violet) contribute to our perception of redness. In addition, our L cones (the long wavelength cones without which we cannot see red) have a small peak of sensitivity in the blue-violet range of the visible spectrum.

Violet, not purple, is the color we see in a rainbow. It would be incorrect to say the visible spectrum is made up of red, orange, yellow, green, blue, and purple. Though violet and purple may be used synonymously in colloquial English, in color science they represent two distinct categories of color.

Blue/violet and red appear to flow seamlessly together to create purple, even though the wavelengths of each are on opposite ends of the visual spectrum. Even Newton's original color wheel joined violet and red despite the fact that his prism experiment showed that the red wavelengths of visible light that exited the prism at the top of the spectrum did not touch the violet wavelengths at the bottom.

29 | What Is Black?

In terms of light, black is the absence of all visible light. In terms of pigment, black is the absorption of all visible light, such that no light reflects back into our eyes.

In reality, black isn't as absolute as it sounds. If you go in a room and shut all the doors and windows, there is still light in the room. However, it is too dim for our visual system to perceive, and so we see black. The same is true for the night sky. There is light from stars and galaxies, but not enough light for our brains to perceive, making the sky appear black.

Perhaps most astonishingly, what our brain perceives as black may not be black at all. Let's imagine a slide with black text projected onto a white screen. By definition, true black—the absence of light—cannot be projected because the projection is created with light. But you can project light onto a white screen and make it look like black text if the white behind the text is bright enough. The black text simply receives little illumination and the white background receives a much higher amount of illumination. In fact, both the "black" text and screen are actually white, but the extreme contrast between the dim and bright whites make the text appear black. (See page 63 for a related phenomenon.)

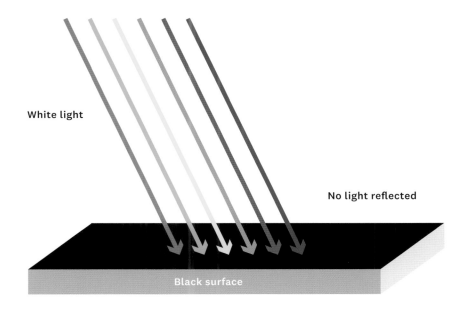

We see black surfaces when all the colors of the visible spectrum
are absorbed by a pigment and no light is reflected.

30 | What Is White?

◼ In terms of light, we see white when we sense the full spectrum of visible light. White objects *reflect* the full spectrum of visible light, or a mix of red, orange, yellow, green, blue, and violet into our eyes.

◼ Therefore, white is a nonspectral color made up of multiple wavelengths of light.

◼ Sunlight, the mother of white light, is created when all the spectral colors are combined. White light can also be produced by a number of artificial sources including LEDs, halogens, and fluorescents. Some artificial lights create white light using full-spectrum light, and others use red, green, and blue light only.

White can be created by a mixture of the entire visible spectrum or by a combination of red, green, and blue light, as our visual system is trichromatic.

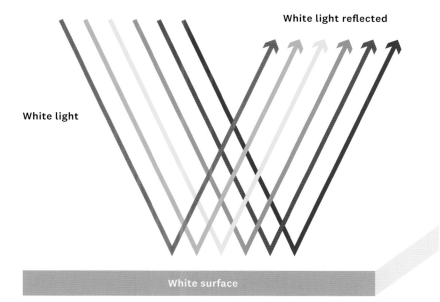

White light reflected

White light

White surface

We see white surfaces when no light is absorbed by a pigment and when red, orange, yellow, green, blue, and violet light is reflected.

31 | What Are Pastel Colors?

■ Pastel colors are an interesting and surprising subcategory of non-spectral color because they are actually a combination of every color of the visible spectrum reflected into our eyes, but at different intensities.

■ Pastel light and pastel pigments are created in the same fashion—by adding white. In the case of pink, for example, most of the light reflected into our eyes (either directly or indirectly via the surface of an object) is red. The rest of the light reflected is white. The trick here is to remember that white light is a combination of red, orange, yellow, green, blue, and violet. That is how white (red, orange, yellow, green, blue, and violet) + even more red = pink.

■ Interestingly, we see gray when red, orange, yellow, green, blue, and violet light are *equally* reflected. If more light is equally reflected, the gray will appear lighter. If less light is equally reflected, it will appear darker; however, it's not just about how much light is reflected, but how dark or light the gray is compared to how dark or light the color is that surrounds the gray. (See page 38 for a demonstration of how the perception of gray is influenced by the color that surrounds it.)

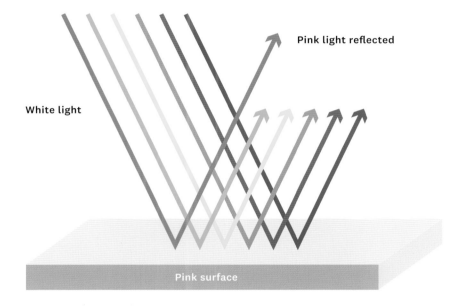

Pink light reflected

White light

Pink surface

Like with white, all the colors of the visible spectrum are reflected by pastel-colored pigments—just not all with the same level of energy. In the case of pink, more red light is reflected than orange, yellow, green, blue, or violet light.

32 | What Are Primary Colors?

◾ A primary color is one of a set of colors that when combined in varying proportions produce a wide range of other colors. Contrary to what most of us are taught, there are no absolute primary colors. The designation of what is primary is arbitrary and has changed depending on the prevailing ideas about color and vision as well as the pigments available at the time.

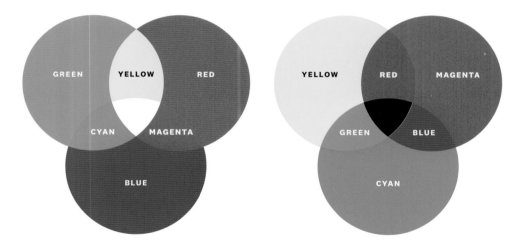

Take note that when you mix the primaries of light,
you get the primaries of pigment and vice versa.

◾ We will follow the convention of most color theory taught today in naming primaries. The primary colors for light are now considered to be red, green, and blue. The primary colors for paint are now considered to be magenta, yellow, and cyan—not red, yellow, and blue, as many of us

are taught as kindergartners (more proof that primary colors change!). Mixing light differs from mixing paint, and that's why the primary colors for light and paint are different. However, they are related. Cyan pigment absorbs red light and reflects blue and green light (blue light + green light = cyan). Magenta pigment absorbs green light and reflects red and blue light (red light + blue light = magenta). Yellow pigment absorbs blue light and reflects red and green light (red light + green light = yellow). In other words, the absorption of the primary colors of light results in the reflection of the primary colors of pigment.

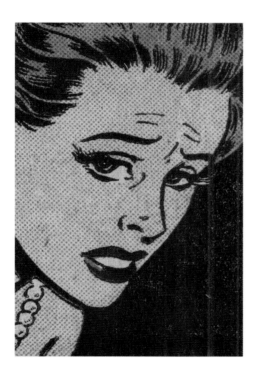

In 1859, the French chemist, Francois-Emmanuel Verguin, invented the first magenta dye. There were no natural magenta pigments up until this point. Of course, magenta existed in nature itself. The petals of myriad flowers let us see this glorious color; we just couldn't reproduce it. Printers were the first to realize the value of magenta. This comic book illustration from the 1950s uses magenta dots not just for the face and lips, but also to enhance the hair color.

■ Contemporary systems have three primary colors of light (and a related three primary colors of pigment) that mirror our three cone types, without which we cannot see red, green, or blue. These three cone types, like primary colors, allow us to see or mix every color in the visible spectrum.

33 | What Are Complementary Colors?

■ Two colors that neutralize each other when mixed in equal measure are called complements. If complements are made up of light, they make white light when mixed. If the complements are pigment-based, they make a neutral color when mixed, desaturating or draining the mixed color of any recognizable hue. Conversely, when complementary colors sit next to each other, each is enhanced and appears at its most saturated.

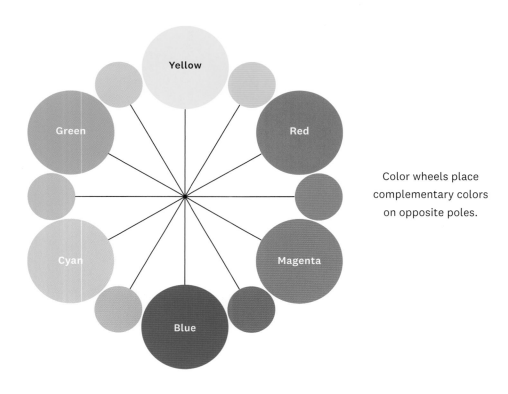

Color wheels place complementary colors on opposite poles.

■ The primary colors of light (red, green, and blue) are the complementary colors of paint (cyan, magenta, and yellow), respectively, and vice versa. Unlike a yellow-green or a blue-cyan, it is impossible to imagine a mix between these complementary colors. There's simply no way to conjure up a magenta-green or a red-cyan.

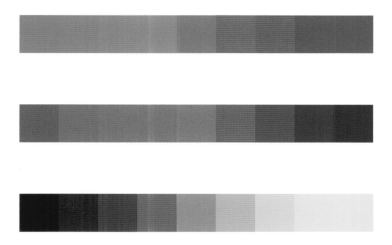

As one complement moves into the other, we watch the color of each disappear into a neutral shade. The middle column of these squares shows equal parts of each complement—just shades of gray.

■ Just as the primary colors are based in our visual system so are these complementary colors. These complements are linked to the opponent pairs we learned about in Question 17. If the activity of the opponent cone types is equal, you get white light. And when you mix equal amounts of complementary paints, you get a neutral. Why are red and cyan complements and red and green opponent pairs? Remember that these primary and complementary colors were invented by humans and are arbitrary, as is the theory of opponent channels. Sometimes the humans don't agree or make sense.

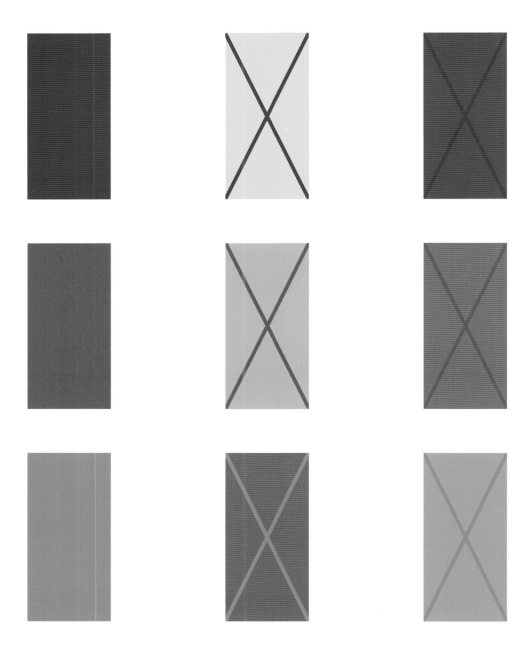

Here, a color (left) is placed on its complement (center) and on a close neighbor (right).
A color looks most saturated when it's next to its complement.

WHAT ARE COMPLEMENTARY COLORS?

34 | What Is Additive Color?

■ Because it's counter to our experience, it's important to hammer home that mixing colors of light is different from mixing pigments. Additive color is a system that describes how the colors of *light* mix together. Additive color is the basis for how color is created on computer screens, TVs, and the colors emitted from LEDs, stage lights in a theater, or any other kind of light source.

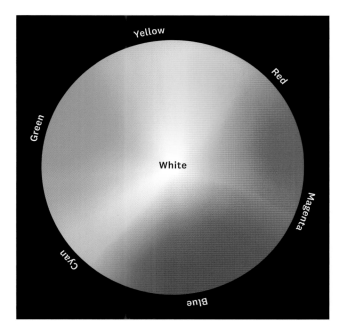

■ When light travels to our eyes, our retina *adds* together the different wavelengths that our cones are sensitive to and compares the activity in each. The result is the perception of a particular color within the visible spectrum.

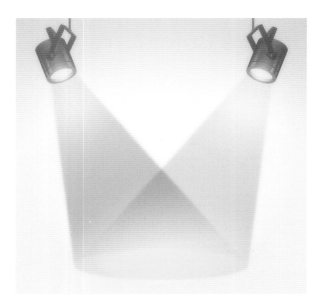

Add red and green light together, and yellow appears. It seems bizarre because when it comes to paint, yellow can't be mixed from red and green. But if you look at the color wheel, the logic is revealed. Just as magenta comes between red and blue, and cyan between blue and green, yellow comes between green and red.

■ Though some colors of light mix similarly to paint, inks, or dyes, others do not. All the colors of light in the visible spectrum, when *added* together, turn to white—an idea completely counterintuitive to what we experience when mixing paint, ink, or dye, because we can't mix pigments to make white. If you remember that black is the absence of light, additive color makes more sense. The more color you add, the closer you get to white.

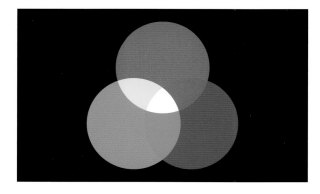

When the color wheel is pared down to the primary colors—red, green, and blue—it becomes even clearer how light adds together. When all three are added together, they make white light.

35 | What Is Subtractive Color?

■ Subtractive color is a system that describes what happens when light comes to us indirectly because it hits a surface first. Some wavelengths of light are absorbed—or subtracted—by the surface, and some are reflected back into our eyes. The subtractive color system is the basis for how pigments mix.

■ Imagine white light hitting a surface. White light is made up of all the colors in the visible spectrum: When white light hits a surface, some of the colors in the visible spectrum are absorbed and others are reflected back into our eyes. When a color is subtracted from white, then another color is suddenly revealed. If a surface subtracts red wavelengths from

white light, we see cyan. If a surface subtracts green from white, we see magenta; and if a surface subtracts blue from white, we see yellow. When you remove a primary color of light, you reveal a primary color of pigment. If all three colors are subtracted then no light is reflected and we see black.

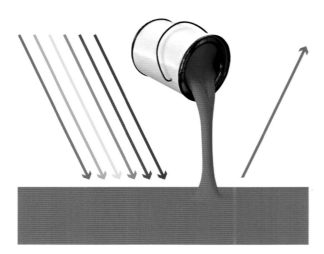

Light hits the pigment in this paint can. Every color in the visible spectrum of light is absorbed by the pigment, except for red. In other words, the absorbed colors are subtracted from the light and only red is reflected.

■ Just like with additive color, we don't need the full spectrum to mix every color of the rainbow. Magenta, yellow, and cyan can mix in different proportions to make millions of colors.

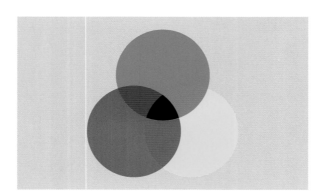

Mix the primary colors of paint all together and the result is black because visible light is absorbed—subtracted—by the pigment. No light is reflected.

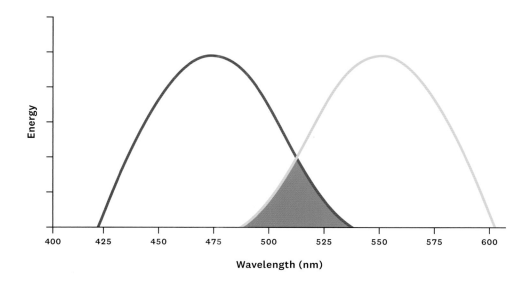

Mix blue and yellow light, and you'll get white. Mix blue and yellow paint, and you'll get green. Remember that blue and yellow light is actually blue plus green and red light (green light + red light = yellow light). When the three primary colors of light mix, they make white. So why does mixing blue and yellow paint make green? Mixing blue and yellow paint gets to the heart of subtractive color. Blue paint appears blue because it reflects blue light and absorbs longer wavelengths of light. Likewise, yellow paint appears yellow because it reflects yellow light and absorbs shorter wavelengths of light. When you mix blue and yellow paint, the result is a paint that reflects a narrow range of green light (per the graph above) and absorbs colors across the rest of the spectrum. We only end up seeing what is reflected, which is just the green light.

36 | What Is RGB?

■ RGB, which stands for red, green, and blue, is the color model used in TV, computer, tablet, and smartphone screens, as well as in other display technologies. It was also used in the first color photographs.

■ Today screens are made up of individual pixels, each with a red, a green, and a blue light source that are too small for the human eye to distinguish. Though your screen may be filled with a purple flower, if you were to put a magnifying glass up to your screen, you'd see red, green, and blue pixels. Take a step back, and the purple flower would appear.

Individual RGB channels and their composite.

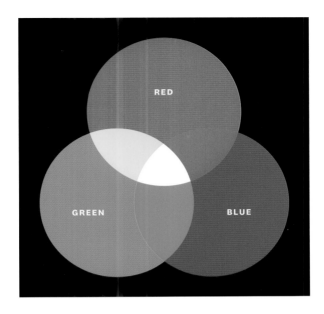

The RGB color wheel is the additive color wheel.

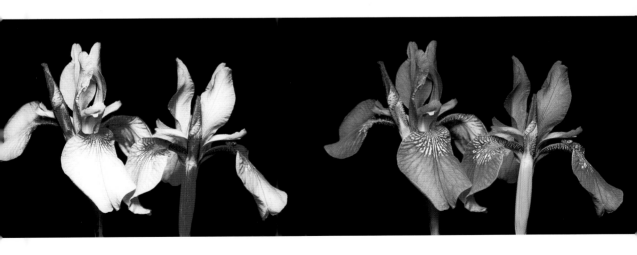

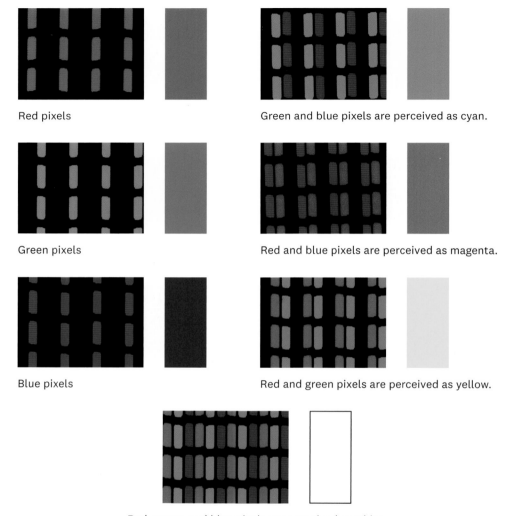

Red pixels

Green and blue pixels are perceived as cyan.

Green pixels

Red and blue pixels are perceived as magenta.

Blue pixels

Red and green pixels are perceived as yellow.

Red, green, and blue pixels are perceived as white.

■ RGB is based on the additive color system where red, green, and blue light mix to create millions of other colors of light, including white. RGB can produce this panoply of color because it correlates to the three kinds of cones in our retina that are sensitive to long, medium, and short wavelengths of light.

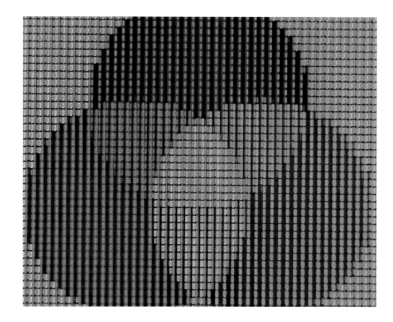

In this RGB color wheel, simulating a screen enlarged to show pixels, red, green, and blue mix to create cyan, magenta, and yellow. Combine all three and they create white.

If you hold this detail of the RGB color wheel at arm's length, you can see how green pixels and red pixels combine to make yellow.

37 | What Is CMYK?

■ CMYK stands for cyan, magenta, yellow, and black and is the color model used in most color printing. The K stands for "key plate," which is the plate responsible for the detail (that is, lines and contrast) in an image. In typical four-process printing, the key plate is black.

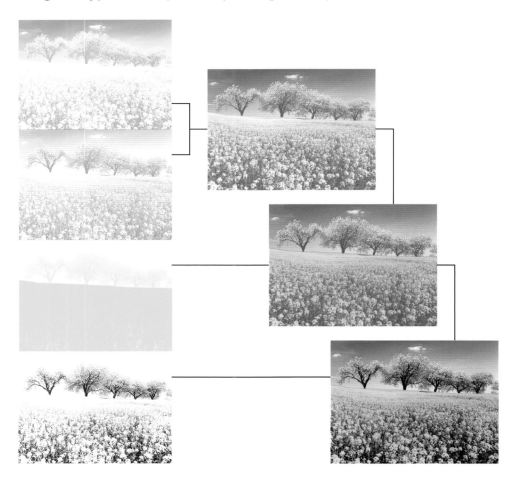

Today most printers create the colors we see on the page through tiny dots of cyan, magenta, yellow, and black ink—dots so small and close together that our brains see them as a continuous field of mixed colors. Typically, each color is printed as a separate plate. Just like with a computer screen, a print made with the CMYK process may appear to be filled with a field of flowers, but if you were to put a magnifying glass up to the paper, you'd see individual dots made of these four colors and nothing more. Take a step back and the flowers would appear.

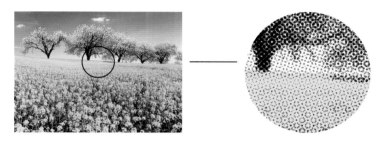

CMYK is based on the subtractive color system, where cyan, magenta, and yellow inks mix to create millions of colors. Cyan, magenta, and yellow are the complementary colors to those in the RGB color model: red, green, and blue.

Opposite: Individual CMYK layers and their composites.

Above: Enlarge the printed CMYK image enough, and the individual dots become visible.

Right: The CMYK color wheel is the same as the subtractive color wheel.

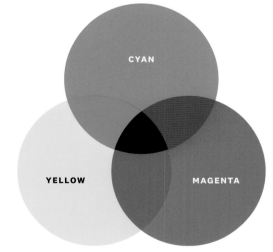

38 | Why Do Colors Look Different on Screens Than on Paper?

■ Here's the easy answer: Screens are backlit; paper isn't. Color appears different when it is made of light versus when it is made of ink.

■ Color that we see on screens hits our eyes directly via the light source itself, as described in the additive color system. Color that we see printed on paper or other materials comes to us indirectly and follows the subtractive color system. Light hits the paper, and the paper reflects back the light that it does not absorb.

■ RGB imaging systems that use light typically display a wider range of colors than CMYK imaging systems that use ink. Therefore, a printed image may look duller and less dramatic than it does on a monitor. Professional printers work to achieve accurate color, but some color information is often lost in the transition from RGB to CMYK.

Here is a simulation of RGB (top) versus CMYK (bottom) color. Both spectrums are actually CMYK because they are printed on paper, but the simulation gives a sense of the differences between the two.

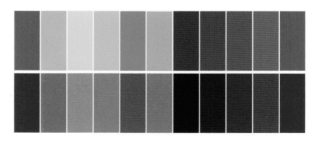

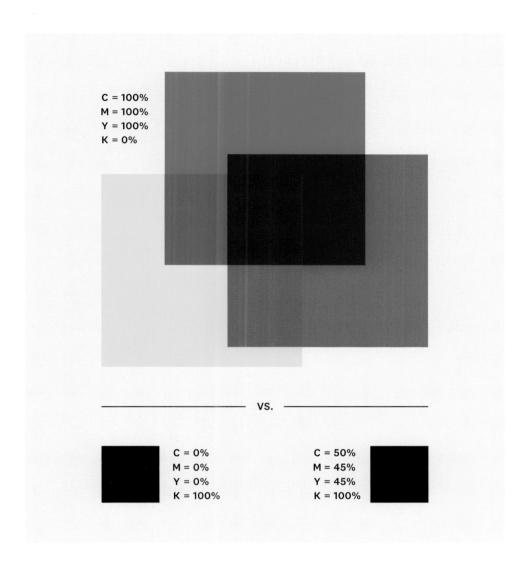

C = 100%
M = 100%
Y = 100%
K = 0%

vs.

C = 0%
M = 0%
Y = 0%
K = 100%

C = 50%
M = 45%
Y = 45%
K = 100%

You might wonder why a black key plate is added to the cyan, magenta, and yellow plates for normal color printing. In theory, if you mix cyan, magenta, and yellow, you'll get black. However, when printers create this mix, the results are disappointing (top). The inks don't usually fully absorb the light, making for a muddy color that is just short of black. Printers can create a more convincing black with black ink (above left), and an even deeper black by mixing percentages of cyan, magenta, and yellow inks with the black ink (above right).

39 | What Is Hue?

■ Hue represents a color without reference to how dull or saturated, or dark or light, that color is.

■ Hue is often associated with the color categorizations we've given to the rainbow—those fully saturated colors we see in the visible spectrum, that is, red, orange, yellow, green, blue, and violet. Purple, which is a combination of red and blue light, is also often included in the list of basic hues. However, the definition of hue varies. In some color systems, many more colors are added under the category of hue, and in others, fewer. It's interesting to note that while black and white are both colors, they have no hue.

■ Hue is often confused with shade. For example, if your answer to "What hue is your shirt?" is "sky blue" or "slate," neither of these answers are hues. They are shades. *Sky blue* and *slate* describe how dark or light and dull or saturated that particular shade of blue is.

The Munsell Color System (see page 124) defines hue with this wheel composed of twenty colors. Each color is fully saturated. No black or white has been added to the hue, nor has any of its complement. However, our language has not caught up to such a color wheel because we don't have generic terms for the hues that fall between red, orange, yellow, green, blue, and violet.

40 | What Is Value?

■ Value is the term used by artists to describe how light or dark a color appears. For example, pink and burgundy are different values of red.

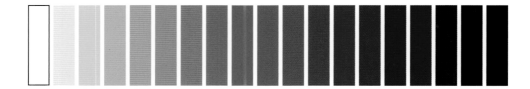

Starting with white and ending in black, the value of red goes from the palest of pinks to the deepest of burgundies.

■ Individual hues lose or retain their value uniquely. For example, yellow loses its value very quickly as black is added to it (it rapidly turns to brown). On the other hand, when white is added to yellow, we can see very small changes from one yellow to the next.

■ There are shades of every hue that are of equal value, even though they may not appear to be at first glance. Colors that become the same shade of gray when they are converted to grayscale are of equal value. Colors of equal value appear to vibrate when they sit next to each other and have been used by artists to make static works appear to move. Artists can also use "inaccurate" colors to accurately convey their subjects (think: blue banana) if the values of the colors are spot on.

The rectangles of color on the left are all the same value as the gray background, which is why they disappear when the graphic is converted to grayscale. This is known as the Helmholtz–Kohlrausch Effect. It is difficult for most people to identify colors of similar value.

We can see how value supersedes color by looking at paintings of faces that get the levels of light and dark right, even if the colors don't make sense. You can tell this from the black-and-white copy, above right, of a portrait by painter Anthonia Nneji, above left. Even if the face is made up of a rainbow of colors, we don't have any trouble recognizing it as a face.

41 | What Is Chroma?

■ Chroma is the term used to describe how saturated a color appears. A color becomes less saturated—or duller—as more of its complement is added. However, to confuse matters, a color can also become less saturated by adding black or white, which we typically associate with value. A color is at its most saturated when it is a spectral color.

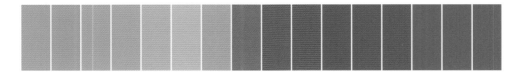

Fully saturated with the highest chroma at each end, the cyan and red
completely lose their color as they mix together.

■ As with value, different hues vary in terms of how slowly or quickly they desaturate. Blues become dull quickly when their complement is added, whereas reds lose their redness more slowly.

■ Value and chroma are closely linked. It is often difficult to distinguish between how dark or light and how saturated a color appears to be.

Light and saturated Light and unsaturated Dark and unsaturated Dark and saturated

It can be difficult to parse out if a color is dark or saturated, light or unsaturated,
or any combination thereof. The colors above show how value and chroma intertwine.

42 | What Is a Color Wheel?

Throughout history, philosophers, scientists, and artists have tried to understand color by organizing it. Many have been seduced by the circle as a way to impose order on what can often seem uncontainable. These circles are called color wheels.

The most familiar color wheels today are based on the very first color wheel created by Isaac Newton in 1672 (page 21). Despite the linear nature of the visible spectrum, Newton joined red and violet at opposite ends of the spectrum. The colors on the wheel that oppose each other also have a relationship. When mixed together, they neutralize or cancel each other out. The seamless connection between colors and the placing of neutralizing (aka complementary) colors across from each other form the basis for the color wheels taught in art classes around the world. What colors make it onto a wheel and what colors they oppose have changed over time and continue to be a point of discussion even today.

The color wheel continues to evolve, and we now see a variety of models that can be asymmetrical, three-dimensional, or both. Modeling of color systems is a sophisticated science that combines mathematical formulas with our current understanding of our visual system. They represent not just the physics of color but the physiology of color as well.

Below: Painter Claude Boutet created this color wheel in 1708, just a few years after Newton's *Opticks* was published.

Above: Writer Johann Wolfgang von Goethe was fascinated by color and wrote a treatise on the subject that included this color wheel in 1809.

Right: Painter Philipp Otto Runge took a giant leap in the history of color theory by turning a wheel into a three-dimensional sphere that included black and white at its poles.

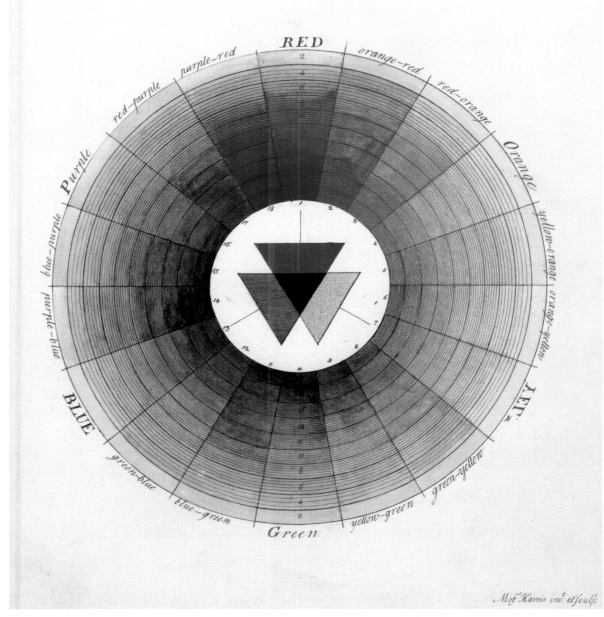

Entomologist and engraver Moses Harris created this color wheel in 1770. Harris believed there were three primary colors—red, yellow, and blue—which mixed to make black (as pictured at the center of the wheel) as well as all the other colors in the rainbow.

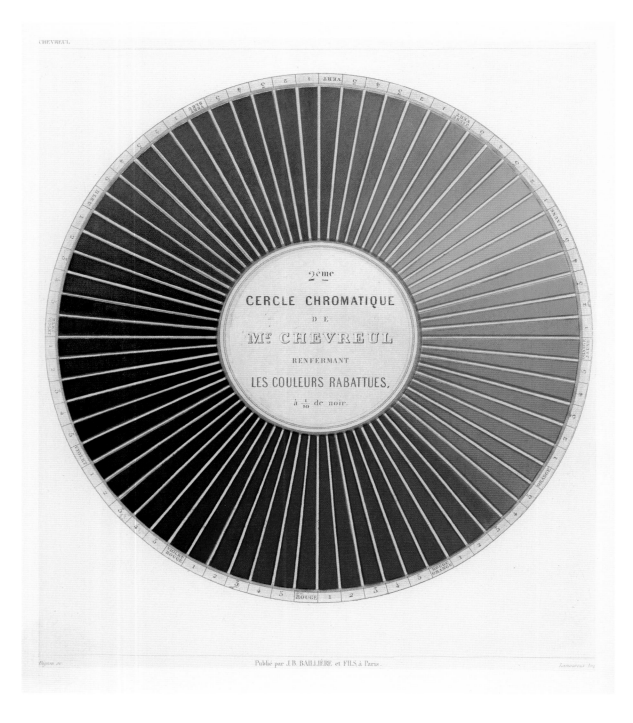

Chemist Michel Eugène Chevruel became interested in color when he worked as the director of dyeing at the Gobelins tapestry works. The weavers complained that black yarns looked different when placed next to blues. His work on the subject, and the color wheel he created in 1861, had a great influence on artists at the time.

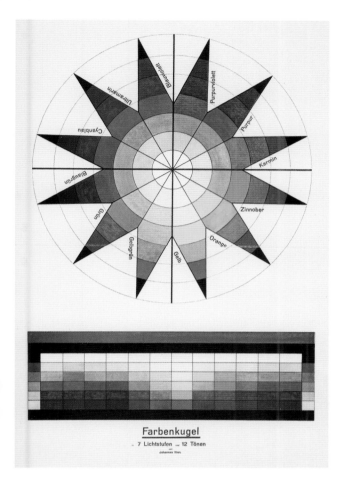

Farbenkugel

7 Lichtstufen — 12 Tönen

Johannes Itten

Above: Psychologist Edwin Boring took the four fundamental colors, plus black and white, presented in Hering's theory of color opponency (see page 55) for this color "wheel" from 1929. However, Boring added a gray center from which all other axes extend.

Left: Painter and Bauhaus theorist Johannes Itten looked beyond pure or primary colors in his color wheel from 1921. He considered seven fundamental categories of color that included, among others, hue, light/dark, and saturation.

Right: The NCS (Natural Colour System) color model developed in 1968 begins with Hering's fundamental colors. It takes into account the breadth and limitations of human color vision, plotting individual colors by hue and how close the color is to black or white, as well as how saturated the color is.

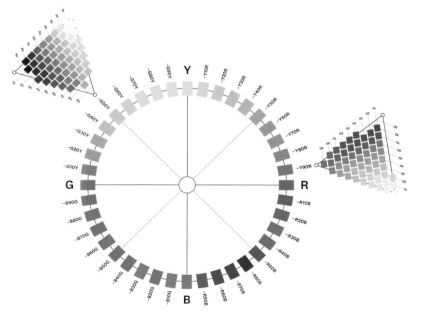

43 | What Is the CIE Color Space?

■ The CIE color space is the most sophisticated color "wheel" to date and the most precise model of human color vision that we have. The International Commission on Illumination (known as the CIE after its French name, the Commission Internationale de l'Eclairage) invented it in 1931. The CIE color space was an exciting breakthrough because it made it possible to pinpoint an exact color with a mathematical formula. Prior to its invention, color matching was done by trial and error—a time-consuming and imperfect process. Suddenly textile companies, printers, carmakers, and the thousands of other industries that require color matching could do so simply and easily.

■ The diagram of the CIE color model shows the range of human color vision. All the colors on the outer ring of the curve represent pure wavelengths of light from the visible spectrum. The colors on the flat line represent colors mixed from red and violet—that is, purples, which are not part of the visible spectrum because red and violet are at opposite ends of the spectrum and don't ever meet or mix. Nonspectral colors are inside the space but are limited to colors that are a mix of only two spectral colors. Draw a line between any two points on the curve, and the colors along that line will be a mix of the two colors. If you draw a line between red and cyan or blue and yellow, you will find white between the two pairs. That's because these complementary colors cancel each other out when combined.

■ This two-dimensional representation of human color vision is limited because it misses entirely nonspectral colors made up of three or more wavelengths of light.

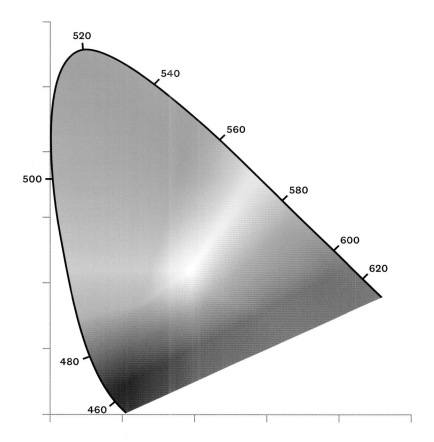

It is important to note that the CIE color model does not represent all the colors humans can see, since it is limited to spectral colors or a mix of no more than two spectral colors. Furthermore, neither the inks on this page nor this image viewed on a computer screen can properly reproduce portions of the CIE color space because of the limitations of both mediums.

44 | What Is the Munsell Color System?

■ Munsell is a color system that was developed in the early twentieth century by Albert Munsell, a scientist and artist, in order to quantify color. The first industry to adopt the Munsell system was the U.S. Department of Agriculture, to identify soil types. Now Munsell is used across multiple industries.

Cross sections of the Munsell color tree, like those pictured here, can be found in Munsell books of color, which serve a variety of industries. There's even an entire book devoted to soil!

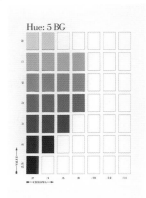 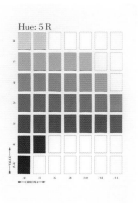

■ The Munsell system was the first to break color out into hue, value, and chroma. By breaking color into these three subcategories, something interesting and profound happened: Color no longer fit on a perfect sphere or color wheel. Certain colors had more dimension when it came to value or chroma, making a three-dimensional and nonsymmetrical model necessary—what Munsell called a color tree. Munsell's system had these characteristics because he based it on actual measurements of human visual responses to color.

■ Organized around an axis that goes from white to black (representing value), horizontal color wheels flank the axis (representing hue); and each wheel radiates from the dullest to the most saturated version of the color (representing chroma).

The Munsell color tree

This top view of the Munsell Color System illustrates how color, as humans see it, does not actually fit into a perfect sphere.

45 | What Are PMS Colors?

■ PMS, or Pantone® Matching System, is a color system that was developed by Lawrence Herbert in 1963 in order to standardize colors for printing. Today PMS is used across multiple industries. Each color in the system is the same no matter where the color is produced, and there are PMS colors that cannot be produced by the CMYK printing process.

The colors in a Pantone formula guide deck (below) are created from the fourteen base colors in the first two columns and the four CMYK colors as shown at right.

■ Theoretically, cyan, magenta, and yellow can create all the colors humans can see. In reality, however, they don't, due to the limitations of ink. Unlike the four-color CMYK color system, PMS colors are mixed from fourteen base colors. Due to the large number of base colors, there are numerous colors that PMS can produce that CMYK cannot.

The yellow line in the CIE color model shows the entire range of colors, within normal human vision, that the CMYK color space covers. The black dots represent the individual colors Pantone covers. As you can see, while Pantone makes fewer colors, some of its colors go beyond the boundaries of possibility of the CMYK model. This is why there's no bright orange in CMYK, but there is with Pantone. Of course, there are still colors even PMS cannot re-create due to the limitations of inks.

■ Each PMS color is mixed in one run, or one screen, to create a solid color, unlike CMYK colors, which are created by overlapping dots produced by four separate screens, one for each color. This is why PMS colors are often referred to as "solid" colors. They are also referred to as "spot" colors because often a single or only a few PMS colors are used alongside CMYK colors. For example, an advertisement with a photograph and a logo would be best printed with both CMYK and PMS colors. The photograph, which could have hundreds or thousands of colors contained within it, would be printed with CMYK. It wouldn't be possible to print with the number of individual screens for each PMS color, and even if possible, the price would be astronomical. On the other hand, the logo would be best printed using PMS colors because either they are colors that cannot be produced accurately by CMYK or a brand wants to keep its logo consistent across all printed materials.

46 | What Is the CRI?

■ Colors are illuminated most vividly by day-light and incandescent light because both of these light sources emit light across the entire visible spectrum. The CRI (Color Rendering Index) is a system that was invented to measure the quality of various light sources, by comparing how closely a color lit by a particular light source resembles that same color in daylight or in incandescent light. The CIE created the CRI in 1965.

■ The CRI employs a scale from zero to one hundred and assigns a number within that range to rate how accurately a particular light source illuminates eight pastel colors as compared to an incandescent light or daylight. A perfect CRI is assigned a one hundred. Although the scale begins at zero, the lowest performing lights rarely dip below seventy. CRI does not measure the brightness of a light source, only the accuracy of how light renders color.

The eight pastel color swatches, known as the Ra-8, that are used to determine CRI.

These supplemental color swatches are not typically used. However, if we had a choice of lights that were rated using these supplemental colors, we could greatly improve the quality of light in our environments. Compact fluorescents and some LEDs don't render saturated red with fidelity (the bright red swatch R9), but you wouldn't necessarily know this by the CRI rating that uses only R1–R8.

CRI 97 CRI 90 CRI 80 CRI 70

The light illuminating the apple to the far left has a high CRI of 97, compared to the apple on the far right, with a CRI of only 70. The apple on the right looks like a photograph that's been darkened and desaturated. Imagine an entire room bathed in light with a CRI of 70. Check the CRI (which is listed on the packaging of all bulbs) before you buy to avoid dreary and institutional lighting.

■ Because the pastels used for measuring CRI do not include saturated colors, a light source with a high CRI does not guarantee that all colors will be illuminated with equal accuracy. Reds are particularly difficult for fluorescents and some LEDs to illuminate properly, even if they score a CRI in the nineties. Examples of lights with a low CRI are high-efficiency, high-pressure sodium bulbs, like the kind you see in street lamps, which score in the low twenties. Fluorescent lights typically span from a relatively low 75 to a relatively high 85 on the CRI. Many fluorescents have spikes in the green and sometimes orange parts of the visible spectrum (creating green and orange casts over whatever they illuminate); some fluorescents with a higher CRI emit light across more parts of the spectrum. Due to the limitations of measuring with the CRI, other colors have been added to the initial eight pastels, and an entirely new rating system, the TM-30-15, has been created. However, at this time, neither is actively used for two primary reasons: First, the numbers originally assigned to bulbs would have to be changed with the addition of the new colors into the CRI test; second, the CRI-100 scale, which TM-30-15 does not employ, makes for a much simpler and easier to understand system.

47 | What Are Warm and Cool Colors?

■ Although there is debate about where they start and end, red, orange, yellow, yellow-greens, and browns are generally considered warm colors, and violet, blue, blue-greens, and stark grays are generally considered cool colors. These categories of warm and cool colors, as they are referred to in art and design, are not scientifically based. In fact, they are the opposite of scientific color temperature scales (page 132), where red is at the cool end of the scale and blue at the hot end.

Fire and ice are the classic examples of warm and cool associations
that informed the idea of warm and cool colors.

The colors we associate with warm and cool colors come from our emotional associations with natural phenomena. When we sit next to a fire or stand under the sun, we feel warm. Fire spans the red-to-yellow gamut. The setting sun also has a similar range. When we touch ice or step out into a steely winter day, we feel cold. The colors of ice and winter span from blues to violets to icy grays.

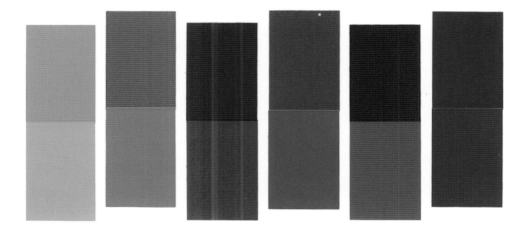

Artist and color theorist Josef Albers challenged the notion that blues are always cool and reds always warm. Here he shows cool pinks/reds alongside blues and warm blues alongside pinks/reds.

Just as warm fire beckons us to come hither, warm colors appear to advance when paired with a cool color, and cool colors appear to recede.

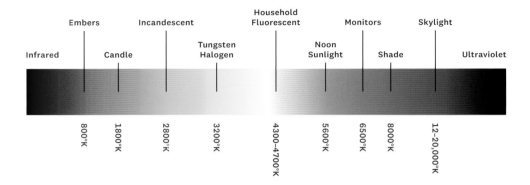

This color temperature graph describes the color emitted by a light source at different temperatures. If you imagine the filament of an incandescent spotlight on a dimmer, you'll get a sense of how color temperature works. If you were to put the dimmer switch very low, the incandescent coil in the light would glow a dim red at around 1000 degrees Kelvin. As you turned up the electricity, the coil would become hotter and glow brighter, becoming a creamy orange white at around 2800K. This is roughly the color temperature of a "warm light" home light bulb. If you continue to turn up the power, the coil will heat even further; and at around 3500K, the light might look pure white to your eyes. If you can push the power up even further, at 5500K, the spotlight will be a dazzling white, with a hint of blue. That is because the color temperature is so high that the lamp has started giving off significant amounts of ultraviolet light. Other lights, like fluorescents or LEDs, do not heat up in this way, so their temperature doesn't actually fall on a degrees Kelvin scale. However, due to the colors they emit, these light sources are still given a temperature based on where they fall on the chart and how they compare to something whose color is directly related to its temperature. Because we associate blue with cold and red with heat, color temperature is counterintuitive. It's hard to fathom that the higher the temperature, the cooler—or bluer—the light; and conversely the lower the temperature, the warmer—or redder—the light.

48 | Can Color Affect Your Mood?

■ The answer is yes and no. Unfortunately, there is very little research on how the brain actually responds to color. Most color psychology "facts" are not based in science.

■ We respond to color in three different ways. The first is our biological response. We do know a bit about how we respond biologically to red objects: They can inspire fear and sexual desire. We also know some things about how we respond biologically to blue light: It can help with everything from seasonal affective disorder (SAD) to issues with our internal clocks to problems with concentration. The second is our cultural response. For example, in the West, blue is far and away the favorite color and yellow the least-favorite color, whereas if you go to the East, yellow climbs to the top of the charts. These differences have to do with cultural associations with various colors. The third is our personal associations with color. Did you go to prison and have to live in a pink cell? Then pink may be a real turnoff to you. Did you grow up with a pink bedroom in a loving, supportive household? Then you may gravitate toward pink.

■ Don't be fooled by claims that peach increases appetite or pink is calming or yellow uplifts. Maybe these are true for some people whose personal, cultural, and biological responses line up to support these claims, but test a different group of people across the globe (or even within the same family) and you may find completely different results. Color surely

Baker-Miller pink, created by psychologist Alexander Schauss in the late 1970s, was used in prisons due to since-debunked studies that were said to have proven that pink calmed prisoners.

can affect mood—put a group of people in a room with fluorescent yellow walls, floor, and ceiling and they're certain to feel *something*—but whether everyone in the room feels the same thing for the same reasons is at this point very hard to prove.

The restaurant Sketch in London, designed by India Mahdavi, uses a similar pink to Baker-Miller, yet evokes an entirely different feeling.

49 | How Does Language Affect the Colors We See?

■ How many colors can you name? What about only shades of blue? Try writing them down. Just getting to ten is hard, even though you can see millions of colors. But once you've seen a color, you're more likely to remember it and recognize it if you know its name. Take Tiffany blue. It probably didn't make your list, but if you've ever seen a Tiffany box, the color will immediately come to mind when you see or hear the name Tiffany blue.

Tiffany & Co. trademarked their signature color in 1998. The color also has its own custom Pantone color, 1837, in honor of the year the company was founded.

■ Paint companies could save millions of dollars by simply numbering their colors, but they've learned how important naming can be for sales. With all the whites to choose from, it's easier for most people to choose a color they know—perhaps a linen white—and be done with it. If you know the name of a color, you're more likely to buy it.

GREEN RED BLUE

PURPLE RED PURPLE

Named after the American psychologist John Ridley Stroop, the Stroop effect demonstrates how our brains process language versus color. In part of the experiment, people were shown names of colors (green, red, blue, and so forth) that were printed in a different color type from the name given, like those above. They were asked to name the color of the type instead of reading out the word. For example, they'd say "red" while reading the word "green" on the top left. There was a universal delay when naming the color of the type if the word itself was the name of a different color. Stroop's conclusion was that the language pathways of the human brain are faster than the color pathways; thus, the Stroop effect reinforces the idea that color naming is an important marketing tool.

■ Color vocabularies around the world have been expanding over human history from the simplest breakdown of color (black and white) to more recent add-ons like orange (which a number of languages still don't contain). Similar to the distinction between red and pink in English, Russians have a word for darker blues (*sinii*) and a word for lighter blues (*goluboi*). When a mid-blue is put in front of Russians, they take a longer time to identify the color because their brains are trying to parse out if it's sinii or goluboi, whereas English speakers can just say blue, lickety-split. Names change what we see. A red by any other name might not appear red!

Голубой & Синий
Russians would call the color to the left *goluboi*
and the color to the right *sinii*, but in English
both would simply be called blue.

50 | What Color Is the Dress?

On February 26, 2015, a photograph of a dress took the world by storm. It wasn't because the dress was beautiful or because the photograph was special. It was because some people saw a white-and-gold dress; some saw a blue-and-black dress; and some saw first one, then the other. How was this possible? It's not like one person saw blue and someone else saw bluish-purple. That kind of color debate happens all the time. Rather, one set of people saw white where others saw bright blue, and gold where others saw black. These are colors that are never confused.

We remember the messages flooding our inbox at the time, *Have you seen the dress? Can you explain it? What color is it?* Confused, Arielle logged on to the internet to find a dress that was obviously white and gold. Joann, on the other hand, saw blue and black. The dress appeared after we wrote our first book about color. Even to us, it seemed impossible. So we stopped looking and started thinking. It seemed like this just might be the single most glorious answer to the question, *What is color?*

Before we delve into an explanation of the great dress mystery, we'd like to take you back to the question we posed at the beginning of this book: In the fall, do the leaves on the trees still change color if no one is there to see them? The answer, we hope you know by now, is *no*. Colors don't exist until we see them. Without eyes and a brain, there's no such thing as color.

The dress isn't white and gold or blue and black. The dress is simply an object, made out of a particular material that when viewed under particular light absorbs certain wavelengths of light and reflects others. Depending on the eyes and brain observing this dress, the light illuminating it,

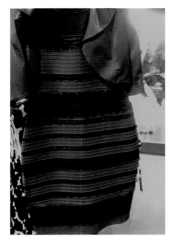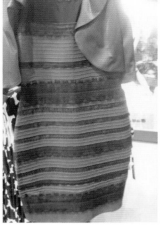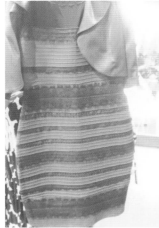

These photos show the blue-and-black dress
some people saw on the left, the white-and-gold
dress others saw on the right, and then a dress
that starts to bridge the gap in the middle.

The swatch to the left interprets what a white-
and-gold dress would look like in shadow. The
swatch to the right interprets what a black-and-
blue dress would look like in bright light. The
swatch in the middle shows how both interpreta-
tions come out of the exact same set of stripes.

WHAT COLOR IS THE DRESS?

and what surrounds the dress, it might appear as white and gold, or blue and black, or even other colors entirely if the observer is color-blind or a bird, a bee, a dog, or a cephalopod.

For most humans with typical color vision, the dress would, indeed, appear blue and black if they saw it in person, in a room lit by a typical light source. Nevertheless, the photograph pulled a real trompe l'oeil on many viewers. Scientists are still discussing and arguing over why different people saw such radically different things. Here's our favorite hypothesis: As you can see from the photograph, it's not clear if the dress is in the shade or in that bright light off to the right side. Those of us who saw white and gold were seeing the dress as underexposed, or in the shade. The eye then adjusted for the shadow and lightened the colors to what they would be if the dress was being viewed in normal daylight. Those of us who saw blue and black saw the dress as overexposed. The eye adjusted for too much light and darkened the colors. This reasoning makes sense, but there are other arguments that also make sense, showing just how complex and resourceful our visual system is.

Through the ages, scientists, artists, and philosophers alike have debated the question: *What is color?* The answer is we still don't really know. While scientists have been hacking away at the physics and chemistry of color for centuries now, the science of vision is still in its infancy. What we do now understand is that color is not simply quantifiable, even if wavelengths of light are. It's almost impossible to believe that what we see isn't objective reality, but like taste, where an olive may seem salty to one person and bitter to another, we can never quite know what red, or any other color, looks like to anyone else.

The mysteries of color abound, but by mastering what is known so far, we can learn to use it to greater effect—whether it be in art, design, fashion, manufacturing, marketing, or any other human pursuit—with the utmost creativity and joy.

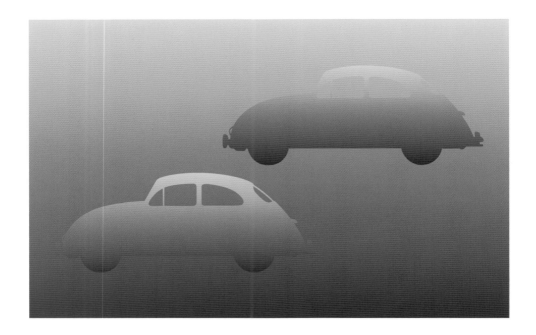

These cars show how the same colors can look completely different. Depending on what we imagine the light in the background to be, as well as how much or how little the background contrasts with the colors, what we see can be dramatically different from the same colors on a white or solid-color background.

WHAT COLOR IS THE DRESS?

Acknowledgments

This book, which started out with a simple premise, ended up being the most complex and difficult project we've ever worked on. For that reason, we have a large number of people to acknowledge.

Jim Levine, our friend, agent, and cheerleader, was his usual source of editorial acumen and support throughout the process. Jim connected us with Eric Himmel, our editor at Abrams. Ashley Albert did an excellent job of editing the manuscript. Eric took over in the design stage and, with his great taste and ability to curate information, helped to shape the final book.

This book would not read anywhere near as smoothly nor explain things as clearly without the help of our aunt/sister-in-law, Samuela Eckstut. At least on three occasions, she set aside everything she was doing in order to edit/copyedit drafts before we handed them off to Abrams. Husband/son-in-law David Sterry provided endless support throughout the project, not just to handle every aspect of the household when Arielle would disappear for days on end, but also to make dull sentences shine. Laura Schenone and Divya Guruju were the perfect readers—the former concentrating on language, the latter on how designers/artists would interpret the material. And Patrick DiJusto came in for a final sweep to make sure all the science was up to snuff. Connor Leonard, Annalea Manalili, Anet Sirna-Bruder, and the rest of the Abrams team shepherded the project all along the way, with its many twists and turns. Thank you!

The scientific community has been exceptionally generous with us throughout this project. Understanding the physics of light was our first order of business when we started the research phase of the book. We only wish we had had Don Smith as our physics professor in college. Thankfully, he acted as our private physics professor for this book. Henry Kandel, another extraordinary teacher, helped fill missing gaps. Lighting designers Patrick Cowan and Scott Herrick, as well as lighting engineer James Hooker shed some serious wavelengths on our understanding of the subject.

Biologists Philip Garnock-Jones, Jon Merwin, Jolyon Troscianko, and Cassie Stoddard helped us with imagery and/or understanding the differences between animal and human vision.

Vision science covers a range of fields, and we were lucky to have a group of these scientists from different corners helping us out. Bevil Conway, Margaret Livingstone, Mark Rea, Wolfgang Einhaeuser-Treyer, and Qasim Zaidi all answered myriad questions. A special thank-you to Qasim for telling us that the first draft of the book wasn't where it needed to be and for helping us to understand what we didn't understand and what we were missing.

Two vision scientists, in particular, gave us more time than we ever could have hoped for. Their patience, goodwill, and ability to explain some of the most difficult concepts in neuroscience were gifts of great proportion. Thank you, Jerry Jacobs and Jay Nietz. We are forever grateful.

The person who connected us to Jerry and Jay, neuroscientist Andrew Huberman, gets a paragraph to himself because he is our book's guardian angel, guide dog, and patron saint, all rolled up into one.

It was pure kismet that we met when we met. We only wish it had been two years sooner, when we first conceived of the book. Andrew is the kind of scientist who knows how to translate any concept into something others can understand. He has a passion for his work that is contagious and that helped sustain us through the difficult parts of this project. Andrew not only read the entire book, but reread individual parts numerous times, sticking with us until we got it right. We'd like to fill every page of this book with thank-yous for his help! Any errors or omissions that remain are, of course, our responsibility.

And then there is Mark Melnick, who not only designed the book, but meticulously created virtually all of its handsome information graphics so that the end result could rise to his high standards. We wanted this book to be equally as exciting visually as it was textually. Mark is the kind of designer who not only intuited our vision, but also made it more refined, more beautiful, more exciting. His investment in the book was way beyond the call of duty, and we are so grateful.

Lastly, a shout-out to daughter/granddaughter Olive Sterry, whose interest in science and the brain inspired us to keep on keeping on.

—Arielle Eckstut and Joann Eckstut

Image credits

Page 7: iStock.com/deepblue4you. 13 bottom: Shutterstock, Prachaya Roekdeethaweesab. 13 top: Christopher T. Weller. 15 bottom: iStock.com/wattanaphob. 15 middle row: iStock.com/ddukang. 15 top row: iStock.com/tanuha2001. 16 bottom: Wikimedia Commons/JustDog/https://commons.wikimedia.org/w/index.php?title=File:LSU_OLE_MISS_1.JPG&oldid=140280912. 16 top: Niels Sienaert. 17 bottom: Anil Goyal. 17 middle: Chicago History Museum, Hedrich-Blessing Collection (HB-62590). 17 top: Chicago History Museum, Hedrich-Blessing Collection (HB-62590). 18 top: Wikimedia Commons/Yuma/https://commons.wikimedia.org/w/index.php?title=File:Milano_Subway_map.svg&oldid=145064367. 20: Wikimedia Commons/Sascha Grusche/https://commons.wikimedia.org/w/index.php?title=File:Newton%27s_Experimentum_Crucis_(Grusche_2015).jpg&oldid=224146887. 21 bottom: Wikimedia Commons/https://commons.wikimedia.org/w/index.php?title=File:Newton%27s_color_circle.png&oldid=224772396. 21 top: Adobestock, Mopic. 24: Ingrid Truemper. 28: Wikimedia Commons/Library of Congress/Photograph by Orren Jack Turner/https://commons.wikimedia.org/w/index.php?title=File:Albert_Einstein_Head.jpg&oldid=330708636. 33 bottom: Bill and Nancy Malcolm. 33 top: iStock.com/quickshooting. 34: iStock.com/energyy. 36 top: Masayo Ozawa. 38 bottom: Beau Lotto and Dale Purves. 39: Shutterstock, Brian Youchak. 40: Joann Eckstut. 43–50: Masayo Ozawa. 51 bottom: UNSW School of Physics, Sydney, Australia. 60 top: iStock.com/JacobH. 59: Shutterstock. 61: Wikimedia Commons/Edward H. Adelson/https://commons.wikimedia.org/w/index.php?title=File:Grey_square_optical_illusion_proof2.svg&oldid=261150959. 62: David Briggs, The Dimensions of Colour/http://www.huevaluechroma.com/. 65: Yale University Press. 70: Adobestock, Gina Sanders. 71 top: iStock.com/Yana Dzubiankova. 78 both: Philip Garnock-Jones. 79 both: Jolyon Troscianko. 74: Xrite Corp. 83: Morihisa. 84: Science Museum/Science & Society Picture Library. 95: Guy Lawley. 99: iStock.com/oleksil arsenluk. 119: Royal Academy of Arts, London/photographer: John Hammond . 120: Science-Sourceimages. 123: iStock.com/PeterHermesFurian. 127: Xrite Corp. 129: iStock.com/t_kimura. 131: Yale University Press. 135: iStock.com/abalcazar. 100 top: iStock.com/d1sk. 102 top: iStock.com/lucato. 104–105 (irises): iStock.com/Natasha Wolf. 106–107 all: Guy Lawley. 108 bottom right: iStock.com/DanielPrudek. 115 bottom: Anthonia Nneji. 115 top: David Briggs, The Dimensions of Colour/http://www.huevaluechroma.com/. 118 bottom right: Getty Trust Open Content Program. 118 left: Album/Alamy Stock Photo. 118 top right: Album/Alamy Stock Photo. 121 bottom: David Briggs, The Dimensions of Colour/http://www.huevaluechroma.com/. 121 top left: Johannes Itten, © 2019 Johannes Itten/Artists Rights Society (ARS), New York/PROLITTERIS, Switzerland. 121 top right: E. G. Boring, "A color solid in four dimensions," L'Année Psychologique (1949) 50, 293–304. 124 both: Xrite Corp. 125 top: Universal Images Group North America LLC/Alamy Stock Photo. 126 left: iStock.com/dja65. 126 right: Xrite Corp. 130 left: Lee Cox. 130 right: iStock.com/Frank Fichmuller. 134 bottom: Rob Whitrow. 134 top: Michael Spafford, Public Domain

Index

Designer: Mark Melnick
Production Manager: Anet Sirna-Bruder

Library of Congress Control Number: 2018936271

ISBN: 978-1-4197-3451-9
eISBN: 978-1-68335-519-9

Printed and bound in China
10 9 8 7 6 5 4 3 2 1

Abrams books are available at special discounts when purchased in quantity for premiums and promotions
as well as fundraising or educational use. Special editions can also be created to specification.
For details, contact specialsales@abramsbooks.com or the address below.

Abrams® is a registered trademark of Harry N. Abrams, Inc.

ABRAMS The Art of Books

195 Broadway · New York, NY 10007
abramsbooks.com

This colored rectangle matches the one on the right on page 75.